IMAGES
of America

ORANGE TOWNSHIP

BETWEEN THE RIVER & THE WOODED HILLS

DECEMBER TWILIGHT BY JULIE LOTAURO.

Here is the place where Loveliness
keeps house
Between the river and the wooded hills.

- Madison Julius Cawein (1865–1914), *Here is the Place.*

QUIET OF WINTER BY JULIE LOTAURO.

IMAGES
of America

ORANGE TOWNSHIP
BETWEEN THE RIVER & THE WOODED HILLS

Vel Litt

ARCADIA

Published by Arcadia Publishing,
an imprint of Tempus Publishing, Inc.
3047 N. Lincoln Ave., Suite 410
Chicago, IL 60657

Printed in Great Britain.

Library of Congress Catalog Card Number: 00-106891

For all general information contact Arcadia Publishing at:
Telephone 843-853-2070
Fax 843-853-0044
E-Mail sales@arcadiapublishing.com

For customer service and orders:
Toll-Free 1-888-313-2665

Visit us on the internet at http://www.arcadiapublishing.com

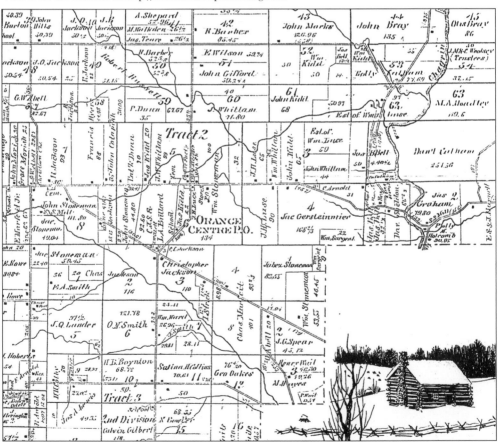

ORANGE TOWNSHIP MAP, DRAWN AS RANGE 10 OF ORANGE TOWNSHIP 7, AS SHOWN IN 1874. (Map courtesy of the Zeidler Family Archives.)

CONTENTS

ACKNOWLEDGMENTS

Without scholars and professionals like Ms. Carla LaVigne, Museum and Programming Director, and Mr. Christopher Gillcrist, Executive Director of the Great Lakes Historical Society and the Inland Seas Maritime Museum in Vermilion, Ohio, this project would not have been possible. I thank them principally for their interest and for the use of materials from the Inland Seas Maritime Museum photographic collection and archives, and for Ms. LaVigne's invaluable aid in the research for this book. The majority of photographs have been generously provided by the directors of the Great Lakes Maritime Museum. Throughout the text, certain images are followed with this photo credit: Vel Litt (V.L.).

My gratitude is extended to Mrs. Lillian Ferguson and other officers of the Gates Mills Historical Society.

Deputy Chief Terry Pristas of the Pepper Pike Police Department has been very helpful in digging deep into the files and records of the Pepper Pike archives. Ms. Sue Molnar assisted in researching documents of early Van Sweringen transactions recorded at Pepper Pike City Hall. My dear friend, Julie LoTauro, has given a special meaning to this work in her reproductions of scenic wildlife as well as for reaching Orange Township in her beautiful drawings. My many thanks to Georgann and Michael Wachter for the use of photographs from their book, *Erie Wrecks*. I also thank Richard Mileti for his scrupulous attention to the details of this manuscript.

I am particularly indebted to Mrs. Connie Novello of Gates Mills for the use of her family's treasured photographic collection and unpublished manuscripts. Mr. Clayton Zeidler's meticulous collection of private and published papers is an important contribution from the Teare and Zeidler family archives. Mr. Ray Burke, of the the Gates Mills Historical Society, provided expert advice and use of resources of their archives and, especially, photographs and memorabilia of early Gates Mills settlers and the introduction of the interurbans. Former mayor of Moreland Hills, Alvin Croucher, and the Moreland Hills Historical Society, contributed photographs and information about the James Garfield history and memorial.

Ms. Carolyn Black and Bakari Jackson provided instruction and gentle guidance through the photographic collection of the Cleveland Public Library. I thank Pat Zalba for access to Chagrin Falls village newspapers no longer in print. Sheila Best and Karen Bossard of the Chagrin Falls Public Library were helpful in locating village photographs. For his inspiration and support, I remember the late Chet Kermode—a dear friend and teacher who provided assistance and patience in researching the history of the Garfield Memorial Church.

I hope others will be encouraged to preserve the photographic and written records of their families. Thank you daughter, Poppy, and son, Stephen, for your enthusiasm, thoughtfulness, and encouragement for this project.

And Jerome . . . without whom . . .

INTRODUCTION
IN THE PRINT OF A MOCCASIN

If a picture can be drawn in your mind of rolling hills and flying clouds, wakeful stars and the hunter pursuing the panting deer, of peaceful streams and winding rivers that lead to falling water over sun-washed stones, then this is Orange Township, U.S.A. before the settlers arrived.

> *Here lived and loved another race of beings.*
> *Beneath the same sun that rolls over your heads*
> *The Indian hunter pursued the panting deer…*
> *The Indian of falcon glance and lion bearing,*
> *The theme of the touching ballad, the hero of the*
> *Pathetic tale, is gone.*

> \- Charles Sprague.

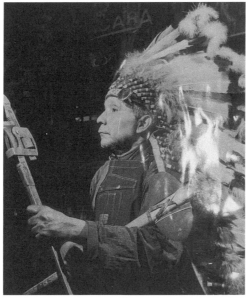

IROQUOIS INDIAN WILLIAM SHENANDOAH. The great-great-grandson of Chief Shenandoah, who supplied George Washington with corn at Valley Forge, is seen in this picture forming a V for Victory with the "tools" of war—the monkey wrench and the tomahawk. (Photo courtesy of Cleveland Public Library Photo Collection.)

> *"Somewhere along the river's edge, a moccasin was all that led . . ."*

> \- Vel Litt

The Orange Village of yesteryear is still here—picturesque—with a special small-town quality. The history of Orange Township is sketchy at best, but there is some formal documentation, especially that which is held in the archives of private family treasures. It is only from the silent print of a moccasin that we can tell the story of the Iroquois, Erie, Cayugas, Hurons, and other Indian tribes who traveled, hunted, and fished in the area along the river long before the purchase of the territory by the Connecticut Land Company. In Gates Mills there is a story attributed to the recollections of Mrs. Cora Hunscher Emery, by her daughters, that "Indians were frequent and friendly visitors in spite of the fact that word had been handed down that they were savage and cruel. They usually came to look for some trinkets or adornments. One day, however, a squaw did come into the house unannounced and put on one of Mrs. Gates' dresses. The squaw danced around for a few minutes, then changed her attire and went away. During this dress parade Mrs. Gates looked on almost paralyzed with fear . . ."

There were blacks in the area, at first to fight alongside Native American tribes just after the Civil War, and later to settle in the part of Orange Township known as Woodmere. There is little recorded history, only photographs of maids and nannies, chauffeurs, and bucks. There were Germans, Irishmen, Scotsmen, Frenchmen, Japanese, Chinese, and the Dutch who came in search of economic or religious freedom. There were men who came to work on the rails and along the canals.

But all in all, Orange Township was not a village of xenophobes. Everyone came from someplace elsewhere. This is not a story of pride or prejudice. These were the years of the great immigration, when hundreds of families with some money arrived. Many came from New England, others from Europe. From New York City immigrants were routed to the steamers from Buffalo onward. This is a photographic history of how the villagers arrived, where they lived, and how Orange Township became the villages of Chagrin Falls, Gates Mills, Hunting Valley, Moreland Hills, Orange, and Pepper Pike. These are the scenic hamlets that we know today.

A SECTION OF CHAGRIN FALLS. (Photo by V.L.)

The first boat on the Ohio Canal left Akron on July 3, 1827, reaching what is now called the Cleveland Flats with a cargo of wool sold by John Brown who died while fighting slavery.

The first travelers found it difficult to reach Orange Township. There were only two ways to cross western New York to reach the Orange area—by boat on Lake Ontario and then the Niagara River, and Lake Erie to the mouth of the Cuyahoga River. The lake steamers let their passengers off at Cleveland, and other passengers who were traveling further south boarded a canal boat at the foot of Cleveland's Superior Street where the Ohio & Erie locked down to river level. Some Indian trails could still be seen. From the Cuyahoga River, these early immigrants traveled along the Ohio and Erie Canals to reach the Tuscarawas River, the Muskingum River, or the Scioto River.

In 1827, because the federal government had financed a pier, a channel was cut in the mouth of the Cuyahoga River. The Ohio Canal was opened from Cleveland to Akron and used for transportation of goods and people back and forth between New York and Cincinnati. Canal usage peaked in 1851. By this time shipping began in earnest. There were 11 steamboats on Lake Erie carrying passengers and freight between Buffalo, Cleveland, and Detroit. Along the canal, many Irish immigrants made their homes. The waterway once earned the name "Irish graveyard" because so many Irishmen lived and died there. James Garfield, the future president of the United States, a 16-year-old newcomer, nearly drowned in a canal lock. Canals were the early highways of Ohio by the mid-19th century.

The Ohio canals that extended from Cleveland on Lake Erie to Portsmouth, on the Ohio River, were a conduit for lake travel. Work had begun in 1825 and was completed in 1832. The canal meandered 309 miles from the Cuyahoga River in Cleveland to the Ohio River at Portsmouth. There were 152 locks that raised or lowered boats about 9 feet and the summit level was 305 feet above Lake Erie and 499 above the Ohio River at Portsmouth. The canals were built to link the lakes, rivers, and newly developed townships. At first the canal boats were pulled by horses in order to reach the lakes. The locks were put in to make travel in each direction possible. The water from the canal spillways powered mills and factories along the way. It was the canal waterway that made Ohio one of the nation's most prosperous and populous states.

With the Indian Removal Act of 1830, all the Indians living in the east were summarily rounded up and deported to reservations west of the Mississippi. Indians who resisted were moved forcibly by the U.S. Army.

When immigrants began arriving in the 1800s, America was in a state of exuberance. America was not the world; it was a country kick-started on the backs of slavery. We were a melting pot of Indians, slaves, and immigrants.

Established by royal authority, the transatlantic slave trade had begun in Britain with the royal family under the direct order of Charles II. The king's family began it and profited from it with the establishment of the Royal African Company. There was, however, alarming bigotry and worry about the "purity of their line" among the English, so when it was announced that "if you freed your slaves you could collect a fortune," Britons let their slaves out into the streets and gave them the liberty to starve. The Britons were paid enormous sums of money to release their slaves. It was a desperate time.

Nearly 50 years after Ohio became a state, Indians still claimed parts of northern and northwestern Ohio. Mid-century would see almost all of Ohio's Indian tribes on reservations in Kansas and Oklahoma.

The Erie Indians, related to the Iroquois, lived along the eastern shores of Lake Erie in New York and Pennsylvania. Though the Iroquois never lived in Ohio, they often traveled there to hunt.

A reminder of those days is recorded in a village story in the *History of Chagrin Falls and Vicinity*, by C.T. Blakeslee, in 1874, and published in the *Exponent* in 1903. It seems a hunter from Aurora came upon the print of a moccasin and at once left his pursuit of other game, and followed the path of the Indian across the Chagrin River.

He discovered the Indian on the other side sitting on a log on top of the rocks just below the falls, on the south side of the river. The hunter then crept along the eastern bank of the river and, with precise aim, made sure of his victim, and the Indian fell over the rocks and was not seen or heard from again.

Blakeslee writes further in some related empathy for the "bereavement of the wife of this ignorant savage." He writes that the death of the Indian and the impending grief of the Indian's wife may have been as keenly felt as similar bereavements were by her sisters of lighter complexion, and of more favored conditions. He stated that after long watching for his return—delay making certain the fact of her husband's demise—the Indian widow gives vent to her vindictive feelings toward all white men.

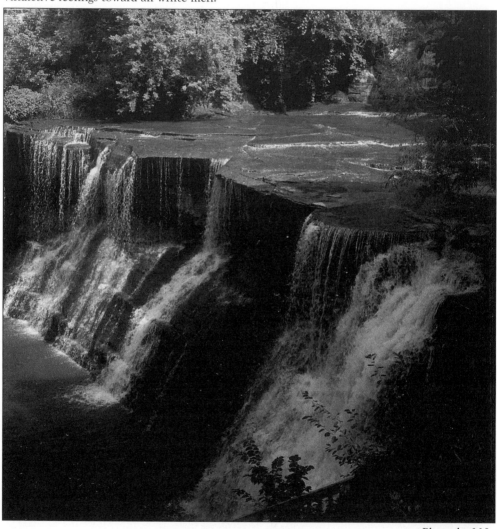

Photo by V.L.

When the storm cloud rolls up the western sky,
And the thunder's voice is loud,
And the raging wind goes fiercely by,
And the lightning angels the cloud
And the darkness comes
O'er the woodland wild,

And the storm beats down
On the forest child,
May the merciless white man e'er be found
Unsheltered and unfed.
While the forked lightnings burn around
The pale-face murderer's head.

When the winter cold o'er the land is spread,
And the Storm King veils the skies,
And the drifted snow o'er the forest dead
And the mighty prairies lies,
When the winds are bold
O'er vale and hill
And in (2 words omitted)
The lakes are still
May the heartless white man e'er be found
Unclothed and unfed.
While the hungry wolves shall howl around
The track the wanderer led.

When the earthquake shall rock and valley and lake,
And the stoutest heart shall quail,
And the rocks and hill shall tremble and shake,
And the solid ground shall fail,
When the earth and sky
Shall gleam with ire,
And the mountain high
Shall burn with fire,
May the soulless white man fall way down
In the yawning chasm dread,
And the face of heaven still on him frown,
And close up the earth o'er his head.

When the summer's suns have passed away,
And the prairie grass is dry,
And the circling fires at the close of day
Light up the evening sky,
As the burning sheen,
By the winds of heaven,
Is onward seen
To the center driven,
May the pale-faced white man here lie down,
Mid the smoke, and heat and flame,
While the raging elements, rushing on,
Leave the field a blackened plain.

When he seeks for food the groves among,
May the gathering storm sweep by,
And the muttering thunder roll along,
The archway of the sky,
And the rain and hail,
And the winds of heaven,
And the forest tall
By the lightnings riven'
Ever fall on the wicked man's head,
And crush him to earth amain,
And the lightning burn up the ground where he died
Lest he grow up to lie again.

When the highest point of the mountain's top
Shall pour out a livid flame,
And a fiery river burning hot,
Through the mountain gorge and plain
Shall onward roll
To the ocean driven,
And a cloudy scroll
Ascend to heaven,
May the white man down the crater be cast,
With all Manitou's power amain,
And the mountain brow be closed up fast,
And ne'er be opened again.

Wherever the white man shall live or shall die
Or whatever name he shall bear,
The prayer of the red man shall go up on high,
And Great Manitou's Spirit shall hear,
And the wrath most dire,
That's in heaven's stone,
In His vengeful ire
On the white man pour,
And the spirit of Cora shall away to the home
Where she'll dream of her husband no more,
And exchange the dark vision of unburied bones
To enjoy his embrace evermore.

From *History of Chagrin Falls and Vicinity* by C.T. Blakeslee, 1874.

THE MIGRATION FROM THERE TO HERE

Most of the material that follows is taken from newspaper accounts, private letters, photographic collections, magazine articles, and community archives. The Orange Township from 1850 to 1950 covers only a small part of a hundred years of development. During that time most of the village area residents were farmers. The Ohio Canal was the only avenue to and from Lake Erie. The villages were undeveloped farmland until the Connecticut Land Company contracted to buy 3,000,000 acres in the Western Reserve along Lake Erie.

The area was divided so that the six most valuable townships were to be sold to settlers only, according to the histories of the Western Reserve. The next best four townships were to be surveyed and called choice land. The next townships were to be divided, parceled off, and added to others of inferior value.

The northern part of the township was high and known as Orange Hill. The southern portion was lower, but swampy. Chagrin Valley comprised the eastern section and was covered with birch, maple, and elm trees. There were abundant deer and bear in the woods.

The population in 1850 was 1,063.

The population of the United States was 23 million, of which 3.2 million were black slaves. By 1950, one hundred years later, the world population was 2.3 billion and the U.S. population was just over 150 million. German immigration to the Cleveland area became a "flood" when Germans were forced out after the unsuccessful "Freedom Revolution."

One

THE ERA OF THE STEAM PACKET

HOW THEY ARRIVED

THE IMMIGRANTS OF ORANGE

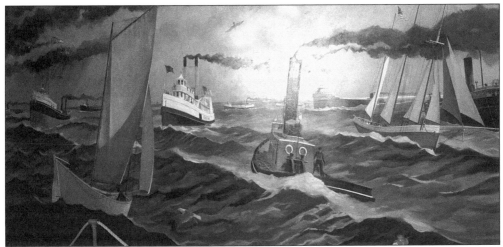

IMAGINARY STORM. This setting, though possibly one of many on the Great Lakes, is an imaginary representation. The season is summer and the time of day is afternoon. A moderate sea is running, the result of a storm earlier in the day. Another storm or line squall moves in from the left. Several herring gulls, familiar on the Great Lakes as well as the greats of the world, go about their business of scavenging. A distant lighthouse warns ships of shoals. The vessels depicted represent some of the types seen on the Great Lakes from 1869 to 1969. (Photo courtesy of the Great Lakes Historical Society, Vermilion, Ohio.)

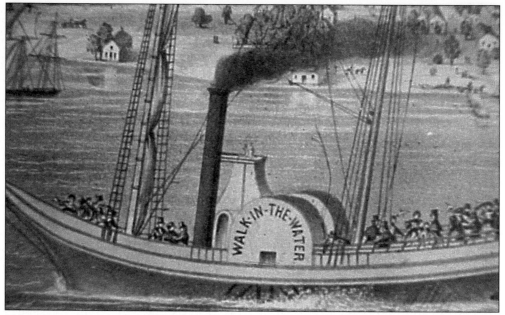

COPY OF THE PAINTING OF *WALK-IN-THE-WATER* FROM THE COLLECTION OF C.M. BURTON.
Copies are from an oil painting by Mr. Matthies, made for Thomas and Mary A.W. Palmer of Detroit, who were returning home from their wedding trip at the time of the disaster. The paintings were obtained by the Great Lakes Historical Society and are held in the Inland Seas Maritime Museum at Vermilion.

Lured by cheap land and new opportunity, settlers began to arrive in the areas around Lake Erie from abroad and from New England. Early in the century, the voyage from England to North America took four to six weeks. German, French, and British passenger ships scheduled weekly sailings to America on the Hamburg-Amerika line, the British White Star, the Cunard lines, and the French Fabre and Compagnie Générale Transatlantique lines. Emigrants, who heard from relatives and others who were living in America, availed themselves of the opportunity to leave their native soil for new lives in the United States. It was not always easy to leave their homelands but they often found transportation to reach the seaports relatively easy.

The ports at Hamburg, Bremen, the Dutch or French ports, the ports at Naples, Genoa, Trieste, Le Havre, and Marseilles were busy with excited crowds of soon-to-be newcomers to the American shores. Steerage was almost always crowded and held little light and almost no amenities. Nonetheless, the immigrants arrived and began their voyages with hope.

In 1892, the United States Bureau of Immigration began using Ellis Island to receive and screen immigrants to America. They entered this country with all that they owned. They prepared themselves for the unknown in their new country. The ships arrived in New York often in a morning breeze. Long Island was a dreamland come true. Under the shadow of the Statue of Liberty, they were greeted. The immigrants, after their baggage was loaded into barges, were taken to Ellis Island, and from there, after examinations, they found their way to secure tickets to their western destinations. There they traveled along the canals to Buffalo where they boarded the ships to sail across the Great Lakes.

The lack of roads was a serious handicap for the early settlers who came to this valley. Household goods were carried in covered wagons, drawn by oxen or horses. The roadways were nothing more than Indian paths or buffalo trails. The land itself was virgin wilderness for the

RESCUE WORKERS ON LAKE ERIE, 1800S.

most part, completely overgrown with forest.

Lake Erie is the fourth largest of the five Great Lakes. With a depth of 60 feet in the shallowest places, it is 210 feet deep in a small area off Long Point. In shallow Pelee Passage, an area off Long Point, there were many collisions and groundings that resulted in ship losses. This period of history of the Great Lakes is one of the most destructive, and reports of tragedy were staggering. The busiest year in lake history was 1850, when 431 souls were lost and thousands of dollars in sunken cargo recorded.

Many experts speculated on the reasons for so many accidents on the Great Lakes. With the rapid expansion of the shipping industry there was demand for employment of even the most inexperienced men. The men were said to be overworked and underpaid. High freight rates tempted owners to overload their ships and captains to take chances with hurriedly and sometimes improperly loaded ships. There was a feeling that the public was not being protected.

According to a public meeting, held at Empire Hall in Cleveland, on Monday evening, July first, 1850 before his honor the mayor, William Case, a report was given on the burning of the Steamer *Griffith*. In the report, it was stated that within a five-month period alone there had been three explosions—the collision of two steamboats and one total destruction by fire, resulting in the loss of 376 lives. There were, in addition, several very dangerous collisions and many fires on boats, where fortunately no lives were lost. It was reported that some laws were too often ignored. And because of the shallowness of Lake Erie and the many sandbars that exist in it, the accidents continued to happen.

The first commercially successful steamboat to appear on Lake Erie was named *Walk-in-the-Water*, later named *The Steamboat*. It is recorded that the unusual name was the result of an observation by an Indian standing on the bank of the river and gazing long and silently at the boat moving upstream without sails. "Walks in water," the man exclaimed as he marveled that

15

the boat was stemming the current, unaided by any power known to him. In his observation, each revolving strike of the paddle wheels resembled steps forward. The *Walk-in-the-Water* was a staunch little side-wheeler with a tall thin stack that left a long dark trail of smoke. The name was taken from the Indian words.

Walk-in-the-Water was built by Noah Brown for himself and others at Black Rock, New York, near the head of Squaw Island, a few miles from the mouth of Buffalo Creek, and a little way down the Niagara River. Under a full head of steam, 14 head of oxen were required to tow her against the river current to the lake. Commanded by Captain Job Fish, her trip from Buffalo spanned 45 hours and 30 minutes. She carried 29 passengers and her highest speed was 10 miles per hour. The vessel was 135 feet long, 32 feet wide, and 8 feet 6 inches deep. Her license, issued August 22, 1818, records 338 burthen tonnage. She carried cabins for one hundred passengers above deck and accommodations for a larger number in steerage. On Sunday, August 30, she appeared off the Cuyahoga on her way to Buffalo where she took on board passengers Dr. David Long, Dr. J.L. Beach, Mr. S.S. Dudley, and Miss L. Morgan. On September 7, she carried 31 passengers including the Earl of Selkirk and suite. Residents along the shore of Euclid could see the lone steamer coming from the east, her tall stack rolling a cloud of smoke trailing far in the rear of the swift, gliding craft. They watched the small ship until it turned its prow toward Cleveland and then returned to their farming.

Walk-in-the-Water was wrecked near Buffalo in a mammoth gale that started on Wednesday night, October 31, 1821. The steamer was unable to make headway against the gale. Captained by her new master, Captain Jedediah Rogers, she was driven across the lake and onto rocks near Point Albino where she was stranded with 18 passengers and a full cargo. The crew and passengers escaped but she was damaged beyond repair. She had plied Lake Erie for two years.

In a work called *American Steam Vessels* (1895), Samuel Ward Staunton collected and recorded views and data concerning vessels of all sorts, and assembled a portfolio that was later exhibited at the World's Columbian Exposition in Chicago in 1893. These drawings, which included *Walk-in-the-Water*, are among the only real accounts of the steamers. In an ironic note of history, Samuel Ward Stanton, a lover of ships, went to his death in one of the world's most famous nautical disasters. He was a passenger aboard the *Titanic*, and died at age 42 on that fateful morning of April 14, 1912.

The passenger business was profitable. As early as 1846, $250,000 was earned for the shipping companies that operated between Buffalo and Detroit, Toledo and Cleveland, Sandusky, Chicago, and Milwaukee. The average was about $3,000 for each trip, according to *Hunt's Merchants' Magazine*, in an article about propeller-driven ships. By 1850 there were 16 first-class side-wheelers and 20 propeller-driven ships of over 300 tons carrying passengers between Buffalo and Chicago. The trip took four days on a fast ship and cost $10 for cabin accommodations. This business was devoted to carrying the swelling stream of immigrants from Buffalo to the Northwest. One line of eight ships was engaged in the immigrant traffic alone. There was, however, a presage of change. In only four years, by 1854, Great Lakes travel would shift from steam to rail.

Opposite: COPY OF "MANIFEST OF THE WHOLE CARGO ON BOARD OF THE STEAM BOAT WALK-IN-THE-WATER." ". . . whereof JOB FISH is at present Master; burthen 338 and 60-95th Tons bound from the Port of Mackinac to the Port of Black Rock June 21st 1819." (Manifest courtesy of the Great Lakes Historical Society, Inland Seas Maritime Museum, Vermilion, Ohio.)

MANIFEST of the whole Cargo on board

Boat WALK-IN-THE-WATER— whereof JOB FIS

Master; burthen 338 and 60-95ths Tons, bound from

Mackinac to the Port of *Black Rock &c*

Marks and Numbers.	No. of Entries.	Packages and Contents.	Shippers.	Residence.	Consignees.
J F W	1	Box	Capt Knapp	Mackinac	John Flo
D Deacon	1	Mascock Sugar	D Deacon	On Board	D Dea
J H Carr	1	Do Do	J H Carr	do	J H Car
J B Stuart	45	Barrels Fish	J B Stuart	do	J B Stu
D G Jones	18	Hams	D G Jones	do	D G Con
do	1	Pack Furs	do	do	do
do	1	Keg	do	do	do
do	1	Box Dry Goods	do	do	do
do	1	Barrel Do	do	do	do
do	4	Boxes Nails	do	do	do
L H	4	Barrels Fish	L Hodge	do	do
Cheesbrough	1	Barrel Fish	Cheesborough	do	do
D D	1	Barrel Fish	D Deacon	do	do

4 0 ARTICLES OF ENTRY.

DISTRICT OF BUFFALO CREEK, } ss.
PORT OF BUFFALO CREEK,

JOB FISH, Master of the Steam-Boat WALK-IN-THE-WATER, having, as the law directs, made oath
consisting of ~~Forty~~ *articles* ~~Black Rock~~ Articles of Entry; and deliver
permission is hereby granted to the said Master to proceed to the Port of *Black Rock* in the *State* of *o*
Given under my hand and seal of office, at the Custom-House of the Port of ~~Buffalo Creek~~, the *Mackinac* day of
and of the Independence of the United States the forty *third* year,

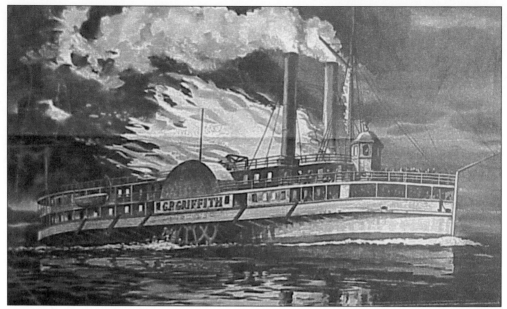

THE *G.P. GRIFFITH*, A PADDLEWHEEL STEAMER BUILT IN 1847, AND LOST ON JUNE 17, 1850. (Photo courtesy of the Great Lakes Historical Society.)

One of the most tragic losses on Lake Erie was the burning of the *G.P. Griffith*. She ranked as the third worst loss of life disaster on the Great Lakes. Built in 1847 by David R. Stebbins at Maumee City, Ohio, she was lost on June 17, 1850, with a cargo of English, German, and Irish immigrants. She was a paddlewheel steamer, 193 feet, 3-inches long; 28 feet, 1-inch wide; and 11 feet, 3-inches deep. She weighed 587 tons. Still scattered at a depth of 20 to 30 feet, she lies one-half mile off the Chagrin River, in Eastlake, Ohio.

No children and only one woman survived the loss of the *G.P. Griffith* that claimed 230 to 290 souls. It was said that the immigrant women were burdened with heavy garments, which often concealed gold with which to start lives in the New World.

It was reported that Captain Roby, Master of the Griffith, was drunk and determined to run the ship to Cleveland. When a fire developed between the stacks at 3:00 a.m., the steamer was steered ashore at Willoughby where she grounded one-half mile out on a sand bar. Flames enveloped the vessel, and all on board were exhorted to save themselves. In the ensuing panic, families flung themselves into the lake. Women fared the worst; many struggled, grasping at each other. About 40 of the passengers and 30 of the crew made it safely to the beach. Many of the bodies were buried in trenches on the beach. The captain, who was on his first trip, was lost along with his wife, mother, two daughters, and a sister-in-law. Only 31 passengers escaped—among whom were the engineer and first and second mates.

The more astonishing part of the story, it was reported, was that the lake was perfectly calm, the water not chilly, and the distance to wading depth not more than 40 rods (250 yards). According to the report, "Not a boat was launched, nor even a door wrenched from its hinges and thrown overboard. A few sticks of wood and the gangway plank were shoved over, but not one was saved by them. In twenty minutes from the first alarm, the tragedy was over, and about 275, out of a little over 300 passengers and crew, had perished."

Much of the passenger business on Lake Erie served to carry the swelling stream of immigrants from Buffalo to the Northwest. In the burning of the *Griffith*, one passenger's letter is particularly poignant. Here follows the complete transcript of a letter of the Henry Priday family, a family who typified those families who settled in the villages around Cleveland.

18

Deer Field, July 23rd 1850

My dear, dear Brother,

 With pain and grief I now will try to make an attempt to address a few lines to you telling you the sad disaster that happened on the Lake Earey on the 17th June. No doubt you received dear Ann Hooper's letter telling you our safe arrival at New York; we then proceeded to Rochester, which is about three hundred and fifty miles, and in going up the canal there was break in it which detained us eleven days. Dear Ann Hooper was very poorly, being staved up in the boat, and by the wish of T. Hooper and my dear Elizabeth I took Ann and the three children and my poor dear Kate to Rochester, which was about a sixty miles from where we was. We was there a eleven days before the boat came. During that time I went to Knowles Ville which is about forty five miles, and there I meet with William, adoing I think very well. He was living with a Mr. Andrews which appeared to be in great style. They was very kind to me and wished me to bring my dear wife and Kate and stop there as long as I liked; It was not my intention to go further than Rochester, but William came back to Rochester to meet his poor dear Mother and Sister and the rest of our dear friends and you must think how glad we was all to see him in a strange land, and he thought I had better go further West and then I consented to go as far as Cleveland which is about sixty miles from Deer Field. We all stopped in Rochester one night and then took the boat to Buffalo on the Friday afternoon and William came with us as far as Knowles Ville which we go there soon after daylight on the Saturday morning, which then he took his leave of us hoping to meet again as the Winter come on. My poor Kate cried very much and said "Father, I am afraid I shall never see my poor William no more." We then sailed on to Buffalo which we got there about four o'clock in the afternoon. We then took the steam boat for Cleveland, thinking of starting on the Saturday morning, but it did not go out till ten the next morning. The distance from Buffalo to Cleveland is 196 miles. Everything proceeded pleasantly through the first day and in the afternoon we were all very comfortable, saying what a wonderful good voyage we had had, barring the break on the canal. We was all in good health after the first week or two leaving Liverpool, all but dear Ann. Thomas Hooper was never sick all the way over, and I never saw him look so well in my life, and remarkable kind to his dear wife and all the rest of us for we was all very poorly for a time. OH, my dear Brother, I must come to the point. All our party went to bed early on Sunday night except for dear Thomas Hooper and my self; we stopped up till twelve o'clock. It just about daylight in the morning I was awoke by some person calling out "The boat is afire"! I jumped out of my berth as quick as possible and my dear Elizabeth heard the awful sound as quick as I did myself. She then ran to where dear Kate and Lydia Humpidge was sleeping and call them up. By that time the smoke and flames were in hot pursuit of us in that part of the boat. I then looked toward the shore and seen as I thought about half mile from shore I thought we might reach that distance, and with all the calmness I could command I did and wished them to do the same; I then look toward the fore part of the boat; there seemed to be no smoke nor flames there. I then got my dear Wife Kate and Lydia Humpidge over the top of the boat and got forward and was followed by Thomas Hooper and his dear wife and Willy. I did not see the two dear little maids nor poor dear Albert Humpidge, but at that moment the boat was put towards the shore. It struck a sand bar and the flames then bursted all over the boat and I believe I had Kate or Elizabeth's hand in my hand as the fire was raging with perfect fury the rush of people quite divided us. I think, my dear Brother, Elizabeth, Kate, Ann and T. Hooper and Lydia Humpidge went over all together and Willy. I was thrust off the other side of the boat toward the Lake. I will leave you, my dear Brother, to judge the state of my mind. I saw a complete mass of emigrants and others rushing overboard and grasping each other. I then went overboard. I went a long way under and as I came to the top someone caught me by my leg but very soon lost me and then something or somebody come on the top of my head and almost drowned me before I made toward shore.

 I started very slow for I saw some sinking before me and on the right and left of me as

appeared to be good swimmers. The distance I think was about a half mile. I could not stand for a long time after I got to shore. I then was bewildered when I gazed on that awful wreck and had lost all that was dear to me I felt for a time as if a merciful God would not allow of such a disaster to have happened, but I hope that good Being will forgive me in my weakness, I do not think it was more than ten minutes after the alarm was given before we was compelled to go overboard or be burnt. The Captain seemed to be as much alarmed as any of the poor emigrants; he never had anything done to save life; he lost his own life. We had got about within 15 miles of Cleveland; the news soon spread abroad and lots of people soon assembled together. There was three boats very soon in search of the bodies; it was thought there was about 350 people aboard and there was 31 saved, but one soon died. Dear Ann and Tom and Willy Hooper was soon found and my dear Kate, but a great distance apart; but in some cases there was seven or eight clasped together. They found that day about 130 bodies; it was very hot that day, and the flies very thick. I put the dear bodies belonging to me straight, and went in the wood and got some boughs and covered them from the flies; then there was a large trench made to put the dead in. I did not know what to do, as I had lost all my money and clothes, but I thought that mine should not be buried in that trench. The Captain was found and his family, which was five or six. They was took to Cleveland. I begged to them to take poor dear Thomas Hooper and his wife and Willy along with them.

There was some money about his person; I gave that up to the parties so that they might be buried decently, which they was. I had not seen my dear Kate when they started for Cleveland but she was found in the morning but a long way off the rest. By that time the dead bodies was took to the trench where I saw 7 put in one upon another.

Oh, my dear Brother, the sight was awful. There was some people there that lived about three miles from that place come very kindly and told me that they would bury my Child at their place at their own expense and all the rest of my familly, which I gladly accepted;My poor dear Elizabeth was not found till the following, Friday, and then she was buried by the side of our dear Kate, Lydia and Albert Humpidge, and Kate and Sally Hooper was never found. I never left the shore for ten days, hoping to find their bodies, but all in vain, I feel very much for poor dear Albert's Mother and Father and for all parties. Mr. Pickering have wrote to Mr. James Humpidge twice but have not received a letter as yet, but do expect to see him every day or hear from him. I do not think as dear Ann or Thomas Hooper ever spoke after I seen them. Poor dear Willy cried and said "My dear Father, what shall we do?" and my dear Kate say "Dear Father, do you think the Lord will have mercy upon us?" I believe I made no reply but I have a hope as the Lord did have mercy upon them. William Pickering came to me on the Saturday following and was very kind and felt very much and offered to render me any assistance as I needed but I did not want anything at that time for the people in that country began to get very kind to me; they had give me a little clothes and some money. The first three days I had no hat and the sun was so hot it burnt the skin off my face. Before I went to Deer Field I went Back to Knowles Ville to see William. Poor dear boy, he was almost out of his mind but I had a great wish to see him and thought it would be better than writing. The distance was five hundred miles there and back, the people of Cleveland paid my passage there and back. I got to William Pickering on the 6th of July; Mrs. Pickering and all the familly is remarkable kind to me and very much grieved at the loss of her dear sister and all the famillies that was lost and they all wish to be kindly remembered to all your familly and Mrs. and Mr. Wheeler. Please to give my best love to my brother Charles and all his familly. I know how much they will feel about it, not forgetting James and all his dear Familly and my dear sisters. I must conclude, with kindest love to you and your dear familly. Give dear Freddy a kiss for me.

I am, my dear Brother,

Your affectionate Brother,

HENRY PRIDAY.

P.S. I do intend to stop at Deer Field till I receive a letter from you and than I think that I shall go in the neighbourhood of Cleveland. I think of writing to Mr. Hooper and poor dear Mrs. Jones in few days. I have no doubt you have received William Pickering's letter by this time. When you write I should like to have two or three lines from your dear Wife. May the God who is in Heaven bless us all.

The name of the steamboat was the *Griffith*, and she burned off the shores of Lake Erie, near Willoughby, Ohio.

The following letter was submitted by OGS member Miss Mary E. White:

The fine steamer G.P. Griffith took fire on Lake Erie, about twenty miles below Cleveland, and was burnt to the water's edge, on June 17, 1850. The passengers were all in their berths when the alarm of fire was given, about three o'clock in the morning. The day had just begun to dawn, and the shore was in sight. At first very little alarm was felt on board, as the boat was rapidly approaching the shore, to which her head was directed. But alas! The prospect of speedy deliverance soon vanished, and every heart was chilled with terror when the steamer, while yet half a mile from land, struck on a sandbar and became immovable.

> *"Then rose from sea to sky the wild farewell,*
> *Then shrieked the timid, and stood still the brave."*

Many of the passengers then plunged madly into the lake, and few of these ware saved. The scene on the burning vessel is represented as one which would have agonized any spectator who had no personal interest in the event. What must it have been to those whose lives, and lives even dearer than their own, were subject to the contingencies of a moment? The consternation of all on board may be estimated from the fact that scarcely any of the survivors were able to give a lucid account of the catastrophe. There were three hundred and twenty-six persons on the boat; of these only about thirty, who were able to swim ashore, were saved. Every child perished, and every woman except one, the wife of the barber. One of the passengers, a Mr. Parkes, had secured a piece of the wreck, which was barely sufficient to support him on the surface, and he was reduced to the horrible necessity of pushing others away when they attempted to sustain themselves on the same fragment. He saw scores of people sinking around him, and heard many a voice exclaiming in piteous accents, "Save me! Save me!" But who can be humane at such a moment? Who can feel pity for others, when his own life is exposed to the most imminent peril? Mr. Parkes says that for a moment he felt like "giving up," and dying with his fellow passengers. But the instinct of self-preservation was too strong for the emotions of sympathy. Soon he found himself almost solitary on the bosom of the lake. Most of the struggling people had disappeared, their wild supplications for aid had ceased and nothing was heard except the sullen sound of the waters as they beat against the charred hull of the steamer.

One of the passengers gives the following account of his escape. He was aroused from his slumber by the cries of fire and the screams of women and children. When he reached the deck he found that the boat was about three miles from land. The second mate gave orders for the boat to be steered towards the shore. She reached the bar half a mile from land, before the flames had made much progress; but as soon as the steamer grounded on that bar, the fire spread with appalling rapidity. One of the officers directed the passengers to save themselves, but did not point out any means of escape. Many of the passengers threw themselves overboard. The narrator says they leaped out of the boat in crowds, twenty at a time. The Captain remained on the upper deck, near his state room, forward of the wheelhouse. When nearly all the passengers had jumped overboard to escape from the flames, the Captain threw his mother, his wife and child, and the barber's wife into the lake, and then plunged in himself. He remained a

moment on the surface with his wife in his arms, and then both sunk together. The passenger who tells this story saved himself on a small piece of plank, supported by which he contrived to reach the shore.

The books of the boat were lost, therefore the names of very few of the victims can be given. But it is known that the loss of life was greater than in any previous disaster on the lake, except only in the case of the steamer Erie. One hundred and fifty-four dead bodies were recovered, and probably from thirty to fifty more remained at the bottom of the lake. The scene on the shore, after the awful tragedy was finished, was melancholy to the extreme. One hundred and fifty dead bodies were strewn along the beach. Boats had been employed in dragging for them at the spot where the wreck lay. A long trench was dug on the shore, and here the greater number of the dead were interred, unshrouded and uncoffined, and many of them unknown.

List of Killed—William Daley; Capt. C.C. Roby, wife, mother and two children; Mrs. Wilkinson; Horace Palmer; Richard Palmer; Charles Brown; Theodore Gilman; Richard Mann; W.P. Tinkham and his two children; Daniel, a colored waiter; Hugh McLair; George Wilmen; P. Keeler; Mrs. Heth and Francis Heth and their children; M. June; W. Tillman; A Ferguson; J.R. Manson; Thomas Wild; an unknown man, on whose person was found one thousand one hundred and sixty dollars; J. Marsh; another stranger, whose clothes were marked with the initials F.P.; Francis Huile; a great many English, Irish, and German emigrants, of who only one, Robert Hall, was saved. Mr. Hall lost his wife and four children, his mother, two sisters and two brothers. Mrs. Walker and child; Selina Moony; and others not identified.

Henry Wilkinson, the clerk of the Griffith, swam ashore by supporting his chin on a piece of firewood. When about to leave the wreck, he first threw his mother and little niece overboard, and endeavored to save them, but was unable to do so, being nearly drowned in the attempt.

This excerpt is from *Lloyd's Steamboat Directory and Disasters on the Western Waters,* Philadelphia. (Courtesy of the Great Lakes Historical Society, Vermilion, Ohio.)

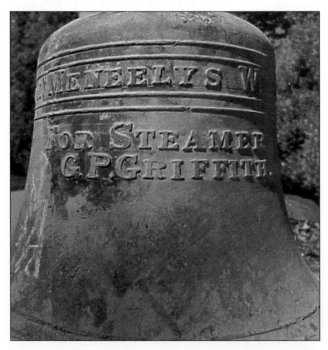

BELL FROM THE STEAMER G.P. GRIFFITH. (Photo courtesy of the Great Lakes Historical Society.)

RESCUE WORKER IN DIVING GEAR. (Photo courtesy of Great Lakes Historical Society.)

DOCK WORKERS FROM THE 1800S. (Photo courtesy of Great Lakes Historical Society.)

From the Detroit Free Press, September 9, 1860:

TERRIBLE DISASTER.

The Steamer Lady Elgin
Sunk, by Collision, in Lake Michigan

OVER THREE HUNDRED LIVES LOST.

Statement of the Clerk

Letter to Superintendent Rice of the Michigan Central Railroad

The steamer Lady Elgin, of the Lake Superior Line, which left here last night, was run into by the schooner Augusta, off Waukegan, at half past 2 this morning, striking her abaft the wheel. The steamer sunk in

On September 8, 1860, the steamer *Lady Elgin* struck a schooner and 297 Irish people perished as a wind rose and waves became higher. After the collision, the *Lady Elgin* lost way and wavered about. Not long afterward she went down. The schooner captain, who was blamed for not stopping longer by the stricken steamer, perished.

Other side-wheelers that were lost were the *Alabama* at 1,200 tons, the *Keyston State* at 1,354 tons, and the *Mayflower* at 1,300 tons.

Articles written by some survivors and other onlookers chronicled the loss of 120 passengers and their baggage. Edgar Andrew Collard wrote about the Pierson family. Ten members of that family, from age 2 to age 44, lost their lives in the explosion of the *Shamrock*, July 1842. They were Allan Pierson, 44; Hannah Pierson, 30; John Pierson, 22; Allan, 20; Robert, 16; Hannah, 7; Sarah 15 months; Mary, 21 years; William, 13 months; and Hannah, 3 years. The passengers were English, Scots, and Irish. Upon another family tombstone was written:

> SACRED TO THE MEMORY OF THOMAS COUSINS
> A Native of Yorkshire
> who perished with about 50
> other Emigrants newly arrived
> from England in the Lake
> a few miles above this Village
> by the blowing up of the Boiler
> on the 9th July 1842
> By this disastrous event
> THOMAS COUSINS
> Aged 42 years
> and his seven children
> ANNE aged 15 Years
> MARY aged 15 Years
> ROSSELIN aged 11 Years
> THOMAS aged 9 Years
> ROBERT aged 7 years
> JOHN aged 6
> DOROTHY aged 4 years
> Were suddenly ushered into the presence of God.

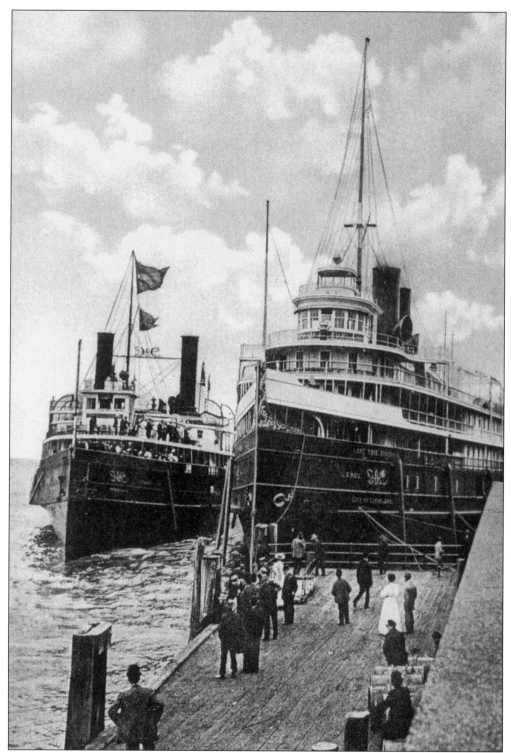

S.S. City of St. Ignace and City of Cleveland, From the D&C Line, At the Dock.
(Photo courtesy of Great Lakes Historical Society.)

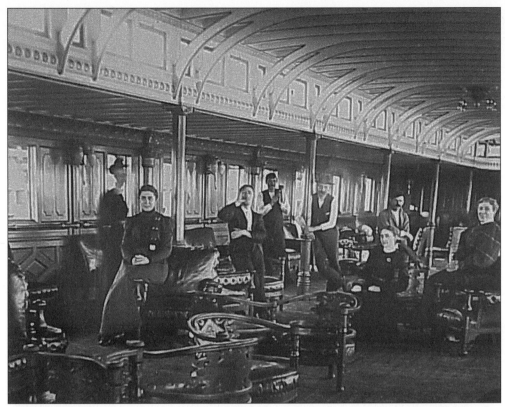

LOUNGE WITH ARC CEILING AND PILLARS IN THE 1800S. The passengers are well dressed.

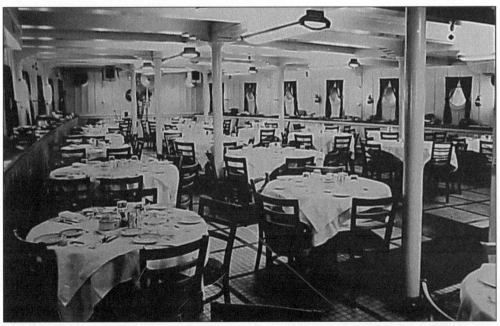

SIMPLE, ATTRACTIVE SHIP'S DINING ROOM. This room reveals the ship's obvious comfort.

CHIEF MEMBER OF BUSY GALLEY STAFF ON BOARD A LAKE SHIP. The ship's galley was the scene of constant commotion. Galley personnel included cooks and assistants, butchers, bakers, and pastry cooks, just as on ocean-going ships of the 1800s.

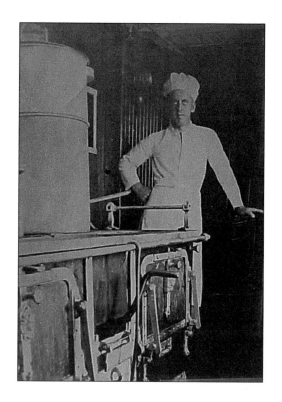

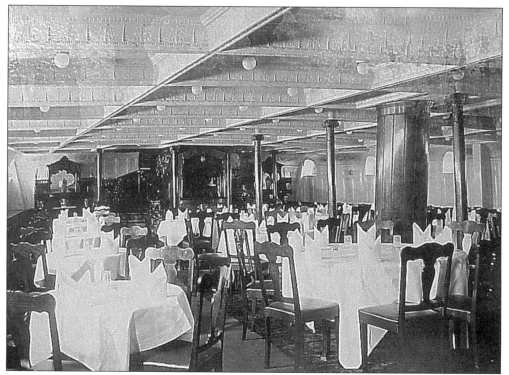

DINING SALOON ON A D&C LINE SHIP.

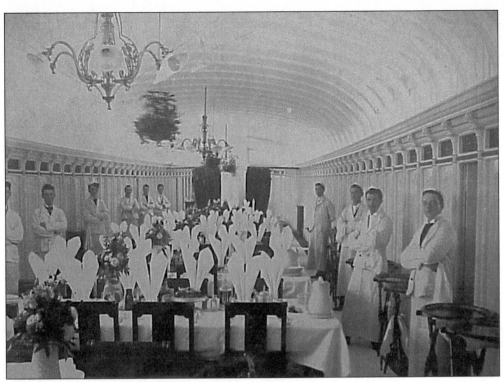

DINING-ROOM STAFF. Note the chandeliers.

A PRIVATE DINING ROOM FOR STAFF.

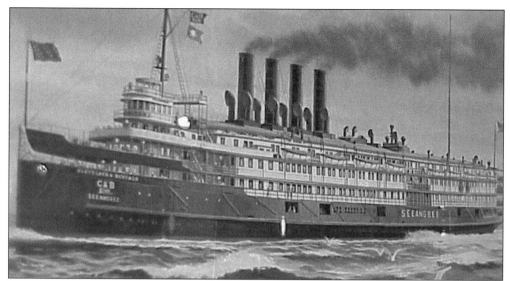

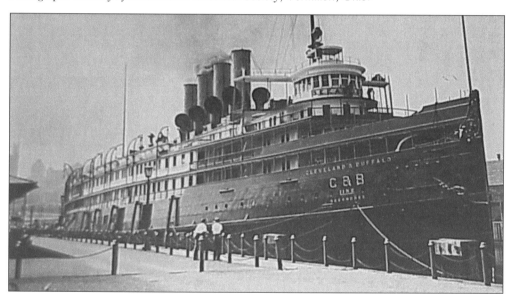

The *SS SEEANDBEE* was the largest side-wheeler passenger ship ever to sail the Great Lakes. Built in 1913 for the C&B SS Company (thus the name *SEEANDBEE*), her keel length was 485 feet, her hull beam 58 feet, and her depth 23 feet, 7 inches. She measured 98 feet, 6 inches overguards. She had the widest deck beam of any ship on the lakes and exceeded that of many oceanliners. The *SEEANDBEE* had four stacks, giving her the appearance of an ocean liner.

Built for overnight service between Cleveland and Buffalo, she was a palatial luxury passenger and package freight vessel and became known as the undisputed "Queen of the Lakes." She had 510 staterooms and 24 parlors and could sleep 1,500 or carry 6,000 day passengers. She could transport up to 1,500 tons of merchandise at a speed of 22 plus knots. She met the most rigid government inspection standards including an automatic sprinkler system. A Buffalo, Cleveland, and Chicago cruise was inaugurated with stops at the Soo Locks and Mackinac Island at a cost of $55 and up per person. These cruises were truly gala affairs with the passenger list limited to 500.

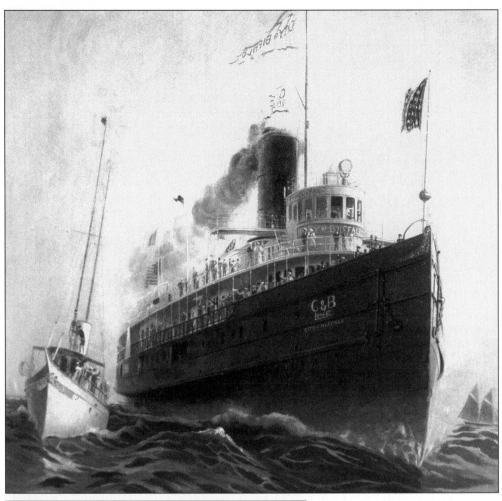

THE CITY OF BUFFALO. This ship was 315 feet in length. The run between Cleveland and Buffalo was 8.5 hours.

THE CITY OF DETROIT. This ship was a part of the Detroit and Cleveland Line. She was built at Wyandotte, and was 295 feet long.

30

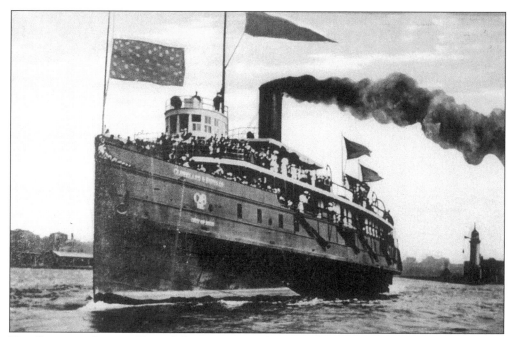

THE STEAMER *CITY OF ERIE*. (Photo courtesy of Great Lakes Historical Society.)

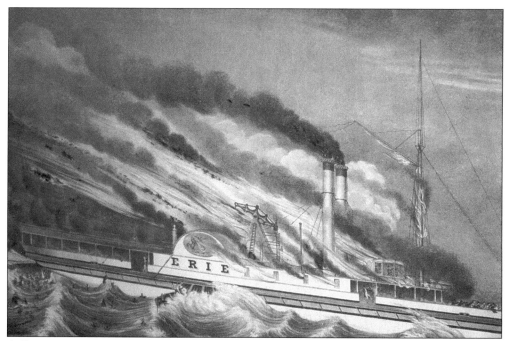

A REPRESENTATION OF THE BURNING OF THE STEAMBOAT *ERIE*. (Photo courtesy of Great Lakes Historical Society.)

CLEVELAND & BUFFALO

C&B
LINE

CITY OF ERIE

UNIDENTIFIED PATRON PICTURED
AFTER THE LAUNCH OF A GREAT
LAKES SHIP. (Photo courtesy of
Great Lakes Historical Society.)

TYPICAL WHEEL AND BINNACLE.
These have been beautifully
preserved at the Great Lakes
Historical Society Insland Seas
Maritime Museum in Vermilion,
Ohio. (Photograph by V.L.)

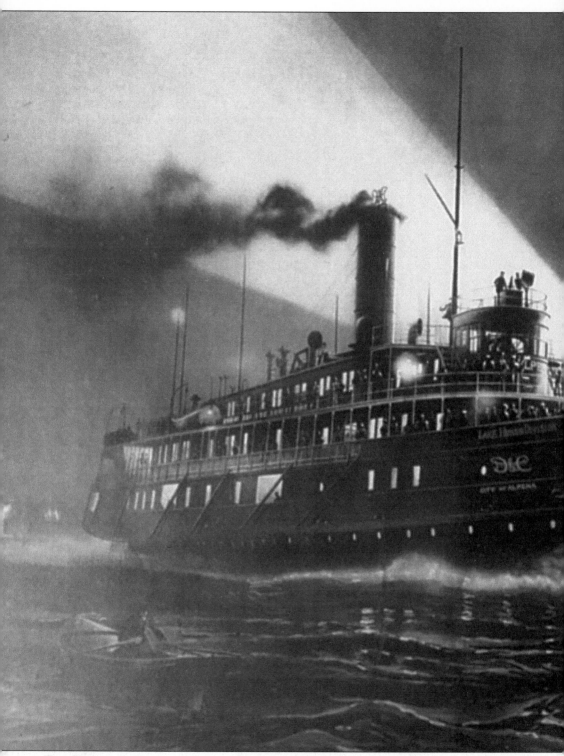

THE CITY OF ALPENA AND CITY OF DETROIT. The ships are shown here approaching Cleveland, and being greeted by an armada of tugs and lights in the late 1800s. This event

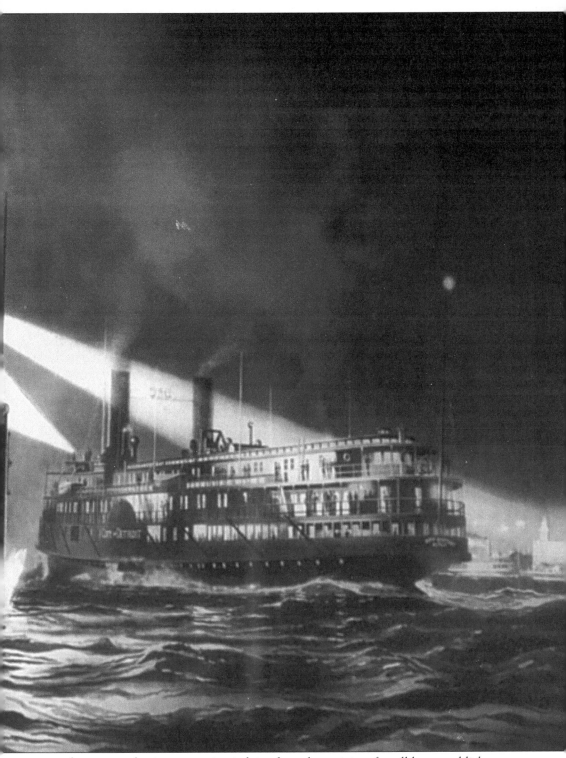

seems to have created quite a sensation judging from the activity of small boats and lights. (Photos courtesy of Great Lakes Historical Society.)

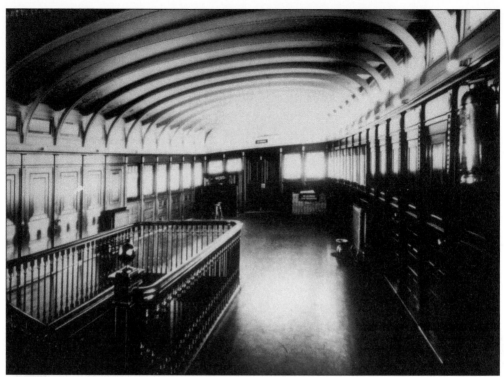

INTERIOR OF A SHIP. The entrances to various passageways can be seen.

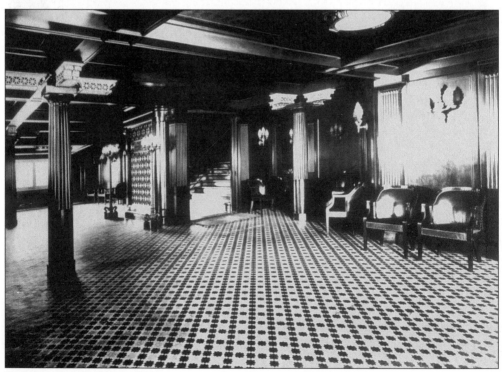

FOYER AND THE GRAND ENTRANCE TO CABINS IN THE SHIP'S INTERIOR.

Two
EARLY FAMILIES
DOWN THE HOG'S BACK AND
ACROSS THE RIVER

THE STONEMAN FAMILY, EARLY SETTLERS.

Orange Township was described in *The Ohio Gazetteer and Traveler's Guide* of 1838, by Warren Jenkins, as "a township in the eastern borders of Cuyahoga county, containing 334 inhabitants at the census of 1830. The post office, called Burnet's Corners, is in this township. It is bounded north by Mayfield, east by Russell, south by Solon, and west by Warrensville townships. It is situated 13 miles from Cleveland, and about the same distance from Willoughby, Aurora, and Hudson. The east branch of the Chagrin River runs across the southeast corner of the township, at which place is situated the Chagrin Falls, the water being precipitated over a perpendicular rock, twenty eight feet; where a village is now being built, which promises to be a place of considerable business.

"The first settlement in this Orange Township was made by S. Burnet, Esq., the present postmaster, in May 1816—seven miles from the nearest neighbors, himself and family being for several months the only white inhabitants of this then new and nameless township. There are now in the township of Orange, about 175 dwelling houses, 700 inhabitants, two taverns, two stores, five saw mills, and seven school houses. The office is supplied with two mails; one from Willoughby, on Thursday of each week, via Mayfield to Salem and back the next day—the other from Newburg, on Friday of each week, via Russell and Warrensville to Cleveland and back on Saturday."

There were other Orange Townships listed in that same register. In the northeast part of Richland County, there was a post township called Orange that posted a population of 1,024. Orange, a township of Shelby County, contained 502 inhabitants. On Shake River in Meigs County, the township of Orange listed 554 inhabitants. There existed a pleasant township called Orange—Orange in the southern borders of Delaware County containing 367 inhabitants. And there was Orange, a township of the new county of Carrol that composed a part of the original township called One Leg and was described as populous and wealthy.

The only approach from Cleveland to Orange Center was Route 87 to the Chagrin River, crossing at Burnett's (*sic*) Tavern, curving into Chagrin Falls past the cemetery at the top of the hill, down the hill, and into town at Chagrin Falls.

In 1830 there had been fewer than 2,000 people in Cleveland. There was much growth in the 1840s and 1850s, and by 1860, the population had grown to 17,034. Cleveland had become a city in 1836. By 1842 there were 109 families in Orange Village composed of 540 individuals. One hundred sixty-nine persons were under 10 years of age, 112 persons from 10 to 20 years of age, 219 from 20 to 40 years of age, 34 from 40 to 60 years of age, and 8 persons over 60.

With the coming of the steamboats the immigrant population continued to blossom. Serious unrest in Europe propelled many Europeans to find new homes and to make better lives in America. The Potato Famine and lack of food in their native land brought the Irish. Crop failures sent rural dwellers in search of work in the cities. Rapid social change in Britain and France promoted revolution and counterrevolution. Social division was pervasive. There were uprisings in Germany when workers and artisans became increasingly dissatisfied with the government, seeing unemployment rise while wages got lower. Foreign intervention in Italian affairs brought great distress when the Pope fled from the country in 1848. In Hungary there were nationalist revolts. The world was not at ease. Many nations were affected by the revolutions. And so began the mass migration across the ocean to America. At the same time New Englanders, with the promise of new opportunity, began to arrive in Ohio.

The financing of a road from Cleveland east to Warrensville and Orange Center facilitated the arrival of many families.

THE STONEMAN FAMILY

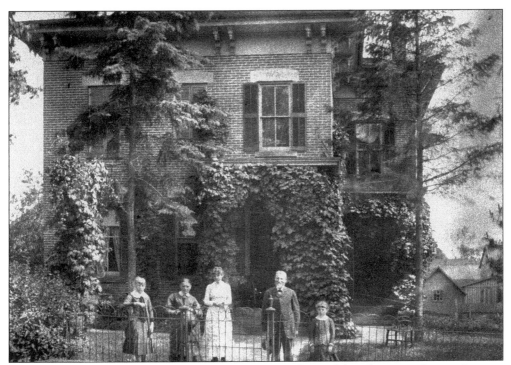

THE JOSEPH STONEMAN FAMILY. The family posed in front of their home on Orange Street, Chagrin Falls, in the 1800s.

This family photo shows the home of John Stoneman the elder. John Stoneman owned the house on Orange Street just a few steps from Main Street in Chagrin Falls. The Stoneman family also settled Lander Circle in Orange Township. They were a large and socially active family. Before coming to America, John Stoneman—the father of Joseph—was an elite member of the Queen's Guard in England, responsible for guarding her majesty. Ann Stoneman, Joseph's mother, had studied medicine with her father who was a prominent physician in England. Joseph Stoneman owned the house built in the late 1800s, and his brother, John Stoneman, owned the farm at Lander Road and Chagrin Boulevard.

Together the Stonemans owned more than 250 acres of property in Orange Township. Mrs. Stoneman was one of those Orange women called upon often by her neighbors and asked to travel to their homes and lend her hand at healing and mending the sick or injured. In addition to this, she kept a home in which the tea-kettle was always filled and boiling, so that a cup of tea might be offered at any time of day or night. According to the records in *Pioneer Women of the Western Reserve*, her son said that he could not recall a time when there was not a preacher in the house. The circuit riders were always welcome guests and it was said that slaves fleeing from bondage over the underground railroad found shelter and rest there. They were carried on to a station nearer the "longed-for goal under the free light of the northern star." The house was open for all travelers who needed a place to stay.

Mr. and Mrs. Stoneman made their home the first stop for friends and relatives coming from England to seek their fortunes in this part of the Western Reserve. Like the other early settlers they were hardworking people looking for greater opportunities for their families. They came predominantly from New England and England during a time when shipwrecks on the lakes and

along the canals were particularly savage.

The Stoneman-Nokes House, as it is now called, in Chagrin Falls, has been entered in the U.S. Department of the Interior's National Register of Historic Places. The house is built of bricks burnt in Stoneman's brickyard in the village. The nomination of the Stoneman-Nokes House is part of a continuing program of the Ohio Historical Society to identify sites in Ohio which qualify for National Register status.

Typically, after arriving in New York from a transatlantic crossing and clearing customs, the families took a steamer up the Hudson River to Albany where they were often packed into a canal boat to cross the state of New York on the Erie Canal. It was a slow and tedious journey that usually took about two weeks.

The men would sometimes jump off the boat and walk along the tow path for a mile or two, then run to get on a bridge that crossed over the canal and, when the boat passed under, they would drop onto the deck.

After arriving in Buffalo, they would take a steamboat for Cleveland. Two months would have passed from the time they had left their homes in England, Ireland, or Germany. An ox cart would bring the families the rest of the way to their parcels of land, which were surrounded by woods.

Mrs. Joseph Stoneman, the former Grace Whitlock, was born in Langtree, England, January 18, 1834. She came to this country at the age of 17. She married Joseph Stoneman in 1854 and settled in Orange township where they resided until 1865, the remainder of their life being spent in Chagrin Falls.

Joseph Stoneman was born in Devonshire, England, in 1825. He came to America with his parents, brothers, and sisters in 1836. Mr. Stoneman served on the village council for several years, and was one of the promoters and stockholders in the Chagrin Falls and Southern Railroad.

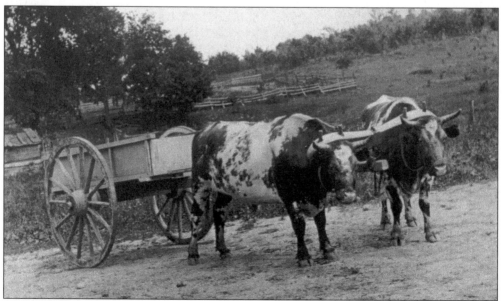

OXEN PULLING A CART IN EARLY ORANGE TOWNSHIP.

THE FAMILY OF WINIFRED TEARE ZEIDLER

Long before the Van Sweringen brothers, Oris Paxton (1879–1936) and Mantis James (1881–1935), began buying the pioneer farms of Orange Township, Winifred Teare's family had managed to build homes and barns for livestock, along with schools for the children of Orange Township.

WINIFRED ZEIDLER'S HIGH SCHOOL GRADUATION IN THE EARLY 1900S.

WINIFRED TEARE ZEIDLER (1897–1992).

In 1840, when William Henry Harrison became president of the United States, John Teare, the great-grandfather of Pepper Pike villager Winifred Teare Zeidler, along with his wife, Jane, and six children, left Kirk Antreas on the Isle of Man in the Irish Sea.

Ships sailed to Liverpool carrying timber and furs from America. These same cargo ships returned to America packed with people determined to find a new life. Conditions were not ideal on many of the ships unless a family could afford a first-class voyage. Usually about two thousand people were crammed into these small vessels.

If the voyage was rough, people did not have enough food to eat. Epidemics often spread throughout the ships. Sometimes entire families died on the voyage across the ocean.

Once the immigrants arrived in America they were examined by doctors at their point of debarkation in New York. When they were found to be in good health they made plans to travel inland. Thereafter it would be weeks—sometimes months—before they arrived in the townships.

In an account given by Winifred Teare Zeidler, the Teare family sailed from Ramsey to Liverpool, England, on a wooden sailing vessel named the *Europe*, enduring six days in a rough sea. They started out again with another very rough crossing. Tensions became strained, the men were seasick, and the passage took nearly six weeks. Arriving in New York City, they sailed up the Hudson River by riverboat to Albany. From there they plied the Erie Canal to Buffalo, ending by lake boat at Fairport Harbor, Ohio. They were headed for the Manx settlement at Warrensville. Oxen and cart were the only means of transportation from Fairport Harbor to Warrensville. There were no roads, which meant it was all an overland haul, mostly by foot.

In time, John Teare bought an 80-acre farm on the north side of Kinsman Road (now Chagrin Boulevard) east of Green Road.

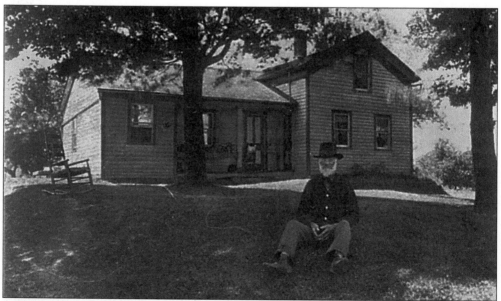

JOHN TEARE AT HIS HOME IN 1880.

POND AND SUGAR HOUSE. These buildings are on the old Gordon farm at S.O.M. Road and North Woodland (later Fairmount Boulevard), on the southwest corner.

"John Teare, my grandfather, married Mary Ann Walkden in 1858. She was born in a log cabin on Richmond Road, on land that became part of Cleveland City Farm. The brick house later built by one of her brothers, Robert Walkden, has been demolished.

"After living one year with her parents, John and Mary Ann purchased their own farm on North Woodland Boulevard (now Fairmount Boulevard) east of Lander Road on the south side of North Woodland. Part of this land now belongs to The Country Club on Lander Road. They bought their land from a Mr. Lockemer, a German who had come from Baden-Baden to this country and had bought considerable land in what was then called Orange Township.

"There was a house and barn on this heavily wooded land. They had to have money (cash) for taxes and sugar, otherwise they bartered for everything, growing wheat, corn, oats, hay, and, in the summertime, potatoes, apples, and other fruits and vegetables to store through the winter. They raised turkeys, chickens, ducks, and geese. They slaughtered their hogs and cattle. They chopped their firewood and heated and cooked with wood-burning stoves in winter and gasoline cook stoves in summer.

"As a means of getting money to pay for the land, and to buy more, my grandfather would take down trees. He didn't want to worry my grandmother who was busy raising six boys. The barn could not be seen from the house because of the many large trees. With horses and chains my grandfather would drag the tree trunks into downtown Cleveland where, as lumber was badly needed there, he sold them. It was a tedious journey. He probably changed horses at a livery, returning the borrowed ones and picking up his own rested horses.

"I was told that the land at the southwest corner of Fairmount Boulevard and S.O.M. Center Road was purchased by the Barber family from the Connecticut Land Company in the early 1800s for 3 or 4 cents an acre. My grandfather's farm on S.O.M. Center Road, now belonging to the Pepper Pike Country Club, was bought for $18.00 an acre from Mary King in 1880. My grandfather built a house, barn, and other outbuildings on it around 1884. Of his six sons, all but the eldest, John Franklin, were born in the house on North Woodland. These were Charles Walter, Ulysses Grant, William Howard, Herbert Seeley, and Ezra Centenniel. Three of the sons became farmers in Orange Township."

- Winifred Teare Zeidler.

PEPPER PIKE SCENE. There are 55 miles of creeks in Pepper Pike. The Vans changed the grading on Fairmount Boulevard and then put in Gates Mills Boulevard. The creeks were mostly filled in.

ENOS WILMONT, EZRA TEARE, AND WILL TEARE IN THE LATE 1880S.

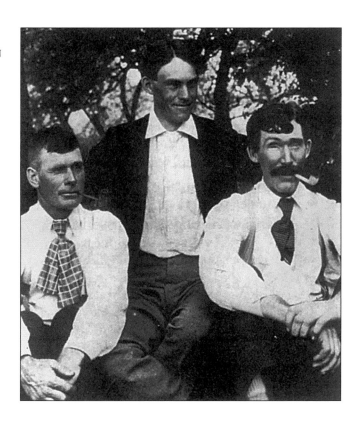

WILL AND EZRA TEARE WITH THEIR DAD.

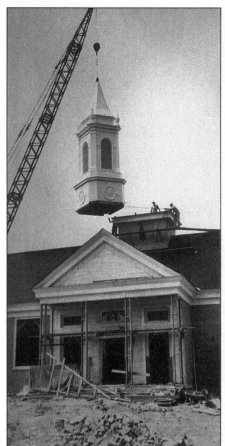

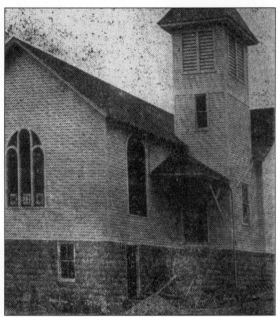

GARFIELD MEMORIAL CHURCH. After his death, Garfield's widow gave a bronze plaque to the church. It can still be seen in the Narthex of Garfield Memorial Church.

THE LITTLE CHURCH AT THE
CROSSROADS

On the opposite page, we see the evolution of one of the first churches in Orange Township. In 1848, the first church building (seen in the upper right corner) was erected in the southeast quadrant of Lander Circle on land owned by Ann and John Stoneman. Gravestones of the Stoneman family and other church members are on the grounds of the original site. A stained-glass window in the present day chapel honors the Stoneman family. The original document to erect a church in 1866 is still in the church and signed by John Stoneman, Ann Stoneman, and other members of the church.

As the church flourished, a larger building was constructed in 1866 on the northeast quadrant of Lander Circle on land purchased from Marella and George Abel. Around 1883, the church was named the Orange Methodist Church. It was renamed Garfield Memorial Church in 1929 because of the closeness of the location to the birthplace of President James Abram Garfield.

In 1929, the church was moved to its present site and President Garfield's son, Abram, headed an extensive refurbishing effort that included the addition of the chapel (the frame part of present building). It was then called Garfield Memorial Methodist Church in memory of President Garfield. At far left, the raising of the steeple of the church can be seen.

The land at the circle was sold for $8,000. When the Van Sweringen developers took over, the church was to be condemned in order to build the new circle at Lander, but it was moved to its present location today.

Lucretia Garfield, the president's widow, gave the church $150 along with a photograph of the late president, which was made into a memorial window. The Garfield children later removed the window and substituted a plaque that can be seen today. (Photos courtesy of Garfield Memorial Church.)

Today, a marble statue of President James Garfield stands in the Rotunda of Statuary Hall of the United States Capitol. Purchased in 1876, the restored Garfield home, now designated as a National Historic Site, is in Mentor, Ohio. In 1881, his widow, Lucretia, added the memorial library and vault in which to store his personal letters, books, and papers. This library set the precedent for presidents to have libraries built in their honor. Congress authorized the property as a National Historic Site on December 28, 1980. The home is now owned by the National Park Service and operated by the Western Reserve Historical Society.

ORANGE'S FAVORITE SON. By the turn of the century, the church affiliated with the Methodists appeared as shown in this striking painting by Glen Shaw. An entry in the Sunday school records from September 3, 1899, notes "very hot and dusty, but forty were present and the collection was fifty cents." Old Kinsman Road (now Chagrin Boulevard) was unpaved but the electric Interurban stopped on its route to Chagrin Falls. Gravestones from the church cemetery still stand on the southeast corner of Landerwood Plaza.

The parsonage and the church were then located with Lander Circle in this depiction viewed toward the southwest. Garfield's son, Abram, drew up plans to move part of the structure to a new location just off the circle. The new church, heavily in debt, took the name Garfield Memorial to honor Orange's brilliant "favorite son." This frame structure dedicated in 1930 remains as a part of the church today. The stained-glass windows in the Fellowship Hall date from 1866.

THE GARFIELD FAMILY

. . . Walked out under the cold starlight and tried to recall the old sensations of boyhood. Here I first learned the constellations and their places in the heavens. It is my Greenwich, where all the world is exactly in its right place. Every other place shows variation more or less . . .

From the diary of James Abram Garfield—1880.

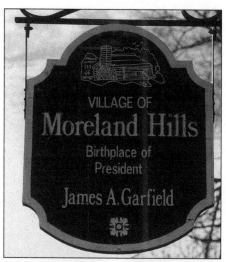

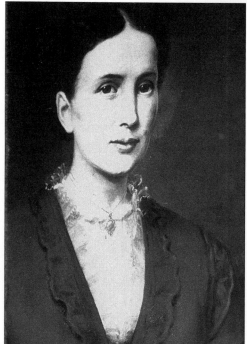 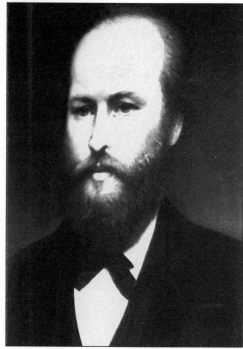

LUCRETIA AND JAMES ABRAM GARFIELD. (Photographs courtesy of Moreland Hills Historical Society.)

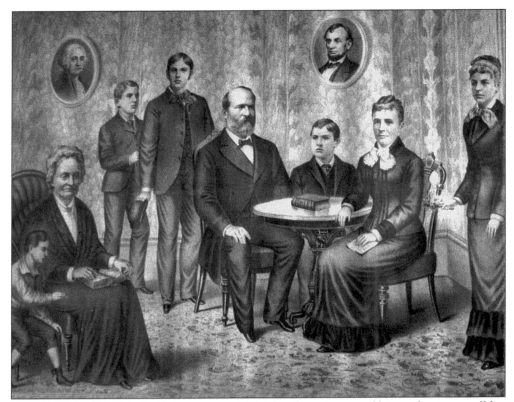

THE GARFIELD FAMILY. Garfield grew up with his brother, sisters, and his mother in a small log cabin. Later he became a lay speaker in the churches of the Disciples of Christ. He enjoyed preaching and often practiced sermons from "pulpit rock," which is located on property adjacent to the restored log cabin in Moreland Hills.

James Abram Garfield, 20th president of the United States, was born in Orange Township, Ohio, on November 19, 1831, in a log cabin south of Jackson and S.O.M. Center Road. Moreland Hills is one of the seven communities that were formed out of the original Orange Township. His father died in 1833 from injuries received while fighting a fire on their farm homestead, leaving the family in poverty. The cabin was later destroyed in a fire in 1850.

"I have planted four saplings in these woods. I leave them in your care," were Abram Garfield's last words to his wife before he died. The eldest child was ten years old, and the youngest, James Abram, was not yet two.

This part of Orange Township was known for its steam sawmills, cheese factories, and farmlands. Beginning in 1897, the Cleveland-Chagrin Falls Railway brought residents back and forth to employment in Cleveland and was also used to take residents and visitors to the amusement park built by John Stoneman at the adjoining Crystal Lake.

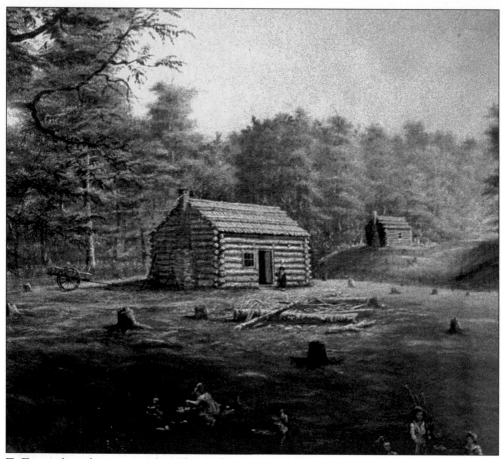

His mother, the young widow Eliza Ballou, continued to run the small farm with the help of an older son, Thomas, and they all lived in a small cabin on the farm. The young widow taught her son to read by the age of three. The children attended schools in Chagrin Falls until Mrs. Garfield gave a corner of her property on which to build a schoolhouse. James Garfield attended Geauga Academy in Chester Township, and, after earning a teaching certificate, he taught school. He later attended Western Reserve Eclectic Institute at Huron, Ohio, and graduated from Williams College in 1856.

Both Garfield boys worked as carpenters. Later, James wanted to go to sea. He walked to Cleveland and, hired by a cousin, became a mule driver for a canal boat. He soon advanced to a higher position, but this short-lived career ended when he fell overboard and nearly drowned.

He returned home and, after a six-month illness, enrolled in the Geauga Seminary where he taught and worked as a carpenter to earn money to continue his education. It was there that he met Lucretia Rudolph, who later became his wife. They were married in 1858.

Garfield was president of Hiram College at age 26. He was a lay preacher and used the lectern, now located in Garfield Church, while giving sermons in the area of Orange Township. He was elected to Congress ten times.

His long career as a politician began in 1859 when he traveled to Columbus as a member of the Ohio legislature. The Civil War short-circuited his tenure in the legislature and he found himself helping to recruit the 42nd Ohio Volunteer Infantry where he became its colonel. He fought at Shiloh in April 1862, served as chief of staff in the army of the Cumberland, participated in action at Chickamauga in September 1863, and emerged as a major general of volunteers.

YOUNG GARFIELD ON THE TOWPATH.

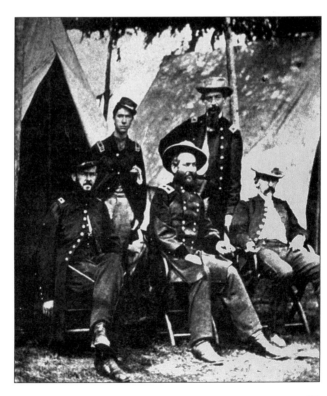

GENERAL GARFIELD AND HIS
STAFF.

GARFIELD AND HIS DAUGHTER,
MOLLY.

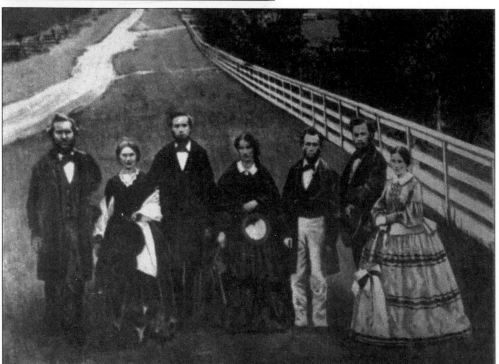

TEACHERS OF THE WESTERN RESERVE ECLECTIC INSTITUTE, INCLUDING JAMES AND
LUCRETIA GARFIELD.

James Garfield was one of the Republicans who, after Reconstruction, still vigorously championed what were then called Negro rights. He served in the Ohio House of Representatives until 1880 when he became a member of the U.S. Senate. In November of that same year, he won the presidency of the United States.

According to A.G. Riddle in *The Life, Character and Public Services of James A. Garfield*, "... Garfield was strong the country over; whose brain was recognized as clear and strong; whose heart every man believed to be in the right place, and whose honesty was above impeachment."

After a vigorous early summer in office, he was to join Mrs. Garfield in Long Branch, New Jersey; she to recuperate from illness, he to take a badly needed vacation. The president had barely passed into the door of the depot when an assassin fired directly at his back. He fell forward as the assailant fired a second shot that cut the left sleeve of his coat.

On July 2, 1881, after only four months in office, the president was assassinated by Charles Guiteau, a disappointed office seeker, in a railroad station in Washington D.C. The villain later paid for his crime at court where he was tried, convicted, and executed.

Doctors attempted to find the bullet using a metal detector created by Alexander Graham Bell, but the wounded president lay on a bed with metal springs, and no one thought to move him. For 80 days, the president lay mortally wounded. He died on September 19, 1881. (Photos courtesy of Moreland Hills Historical Society.)

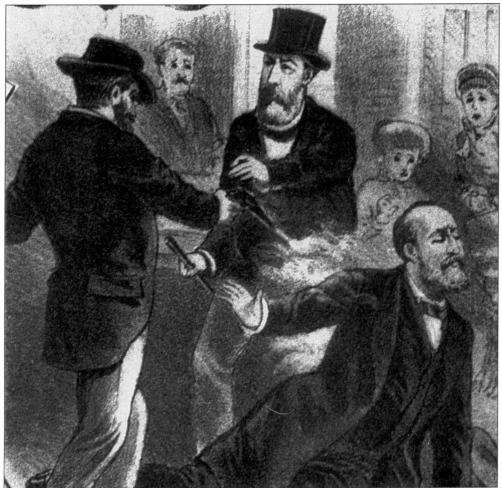

THE FATAL SHOT.

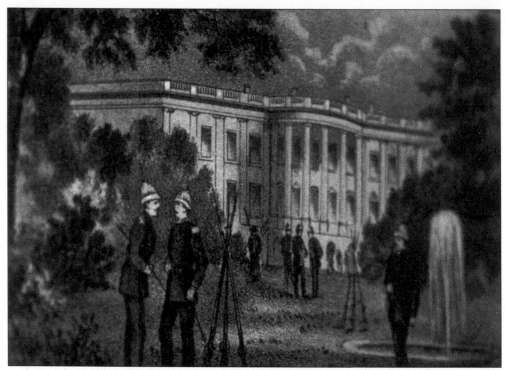

Soldiers Standing Guard Near the White House.

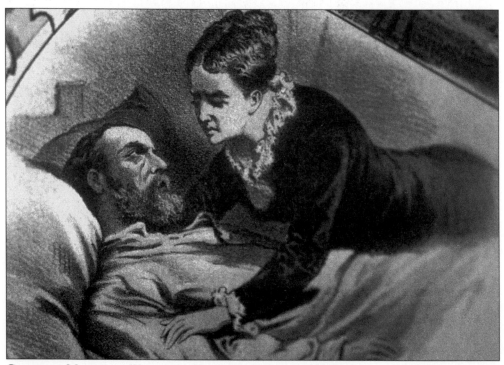

Garfield, Mortally Wounded, With His Faithful Wife.

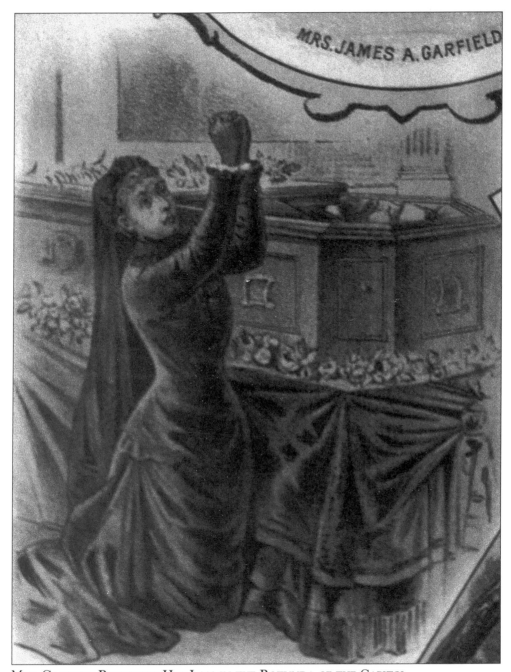

MRS. GARFIELD BEWAILING HER LOSS IN THE ROTUNDA OF THE CAPITOL.

JAMES ABRAM GARFIELD
MEMORIAL—LAKEVIEW CEMETERY,
CLEVELAND, OHIO.

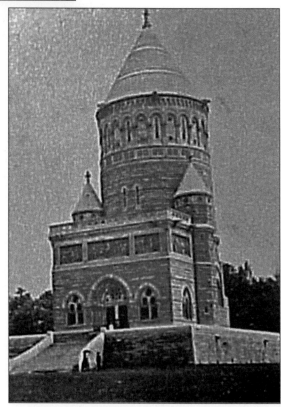

(Photos by V.L.)

Three

ONCE UPON A RIVER

The hills around our village are beautiful, romantic and inviting localities, which at no distant day will be ornamented ground. The people are already building on our higher grounds, and before many years all these surrounding elevations will be pleasant locations of romantic homesteads. As wealth increases it will be expended in erecting ornamental residences, out of the general business thoroughfares. These hills are waiting to be occupied for such purposes, and they will not be long in waiting . . .

–C.T. Blakeslee, 1874

CHAGRIN RIVER FLOOD OF 1913. The falls beside the popcorn shop in Chagrin Falls, Ohio, are shown during the Chagrin River Flood of 1913.

CHAGRIN RIVER IN GATES MILLS. Many of the early settlers made their homesteads near the rivers because water was so important to transport goods or to make provisions for travel, as well as for building and maintenance. Wheelwrights, blacksmiths, harness makers, and sawmill owners were important for the survival of early communities. (Photograph by V.L.)

Holsey Gates came from Connecticut. He was a pioneer of strong character according to the writings and memories of those still living in Gates Mills. He selected a favorable site on the river, built a sawmill and then a gristmill in the woods, and by his force and leadership attracted others to the spot.

Holsey Gates was born on January 1, 1799, in East Hampton, Connecticut. He married Lucy Ann Bradley July 21, 1826. He died in Gates Mills on October 26, 1865. This photograph was taken December 23, 1863.

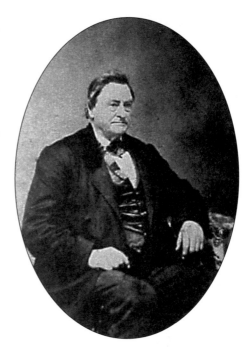

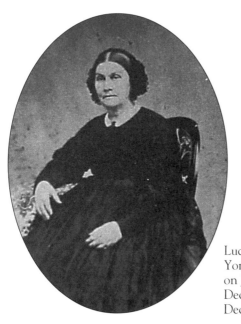

Lucy Ann Bradley Gates was born in Delhi, New York on April 15, 1803. She married Holsey Gates on June 21, 1826, and died in Gates Mills on December 10, 1875. This photograph was taken December 23, 1863.

61

After the arrival of Holsey Gates, a wagon factory, a chair factory, a rake factory, a potash factory, and a gun factory were established. A stage road built from Cleveland to Pennsylvania preceded the construction of a tavern and other houses.

According to the writings of S. Prentiss Baldwin in *Remaking A Village*, ". . . we bought a village and the surrounding hills. With the growing prosperity of the community, the loghouse period vanished and the simple, beautiful lines of architecture of the New England village appeared . . . The influence of the transformed village spread to the surrounding country. The village lies nestled among hills, these hills cut by ravines and broken by wooded bluffs, and great tracts of hundreds of acres were without roads to afford access to the bluffs."

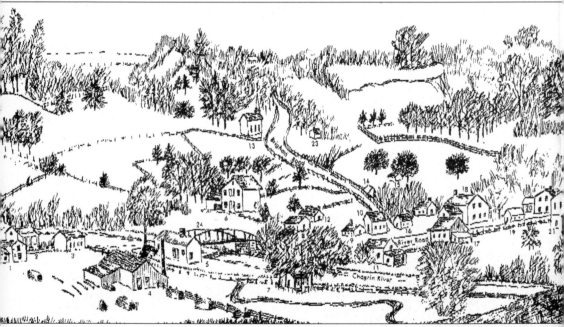

An 1870 Oil Painting of Willson Mills, as Painted By a Sawmill Worker Whose Name Remains Unknown.

SOUTHWICK HOUSE

The Southwick House is a landmark of the Chagrin River Valley. It adjoins the Chagrin Valley Hunt Club where it serves as a museum for the Gates Mills Historical Society. The Southwick house was built about 1834 by Lemuel Southwick, who, with his wife Rhoda Arnold, came from New York State by canal to Buffalo, and then to Cleveland on the *Walk-in-the-Water*—the first steamship to ply the waters of Lake Erie. In the fall of 1821, on her last trip of the season, the *Walk-in-the-Water* was wrecked near Buffalo in a terrible storm while all her passengers were at supper.

The Southwick family met at the family homestead in January 1999, in Gates Mills, to attend the funeral of an aunt. They used the occasion to reminisce, from stories they had heard, about the early days and hardships of living on a farm in pre-Civil War days in Ohio.

The senior Southwicks recalled from their parents that children occupied the one large bedroom on the second floor of the home. Children under the age of three were designated to sleep in cradles outside the bathroom, and only after their third birthday would they be allowed to join their older siblings. The parents slept in the other small bedroom.

The family gave the historical society a large carpenter's wooden tool box made and used by Peleg Sherman in his sawmill. They also donated a large cast key for the historic sawmill.

In attendance were Linda Southwick Morse, Lydia Southwick, Chris Southwick, Brad and Terry Southwick, and descendents of the Sherman family.

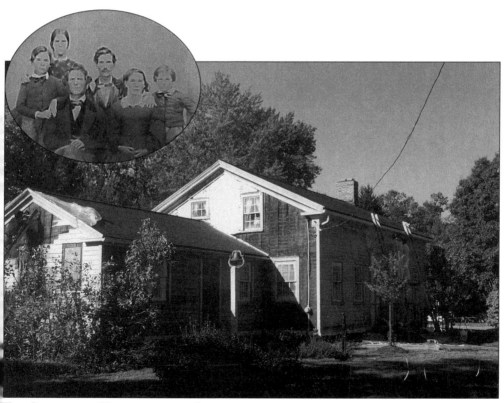

THE SOUTHWICK HOUSE AND THE SOUTHWICKS.

There are six alcove areas on exhibition in the Southwick house. One section shows a diorama of an early manufacturing center with log cabins, and a gristmill with a working water wheel. This area is dedicated to the late George Brown, who constructed the building replicas.

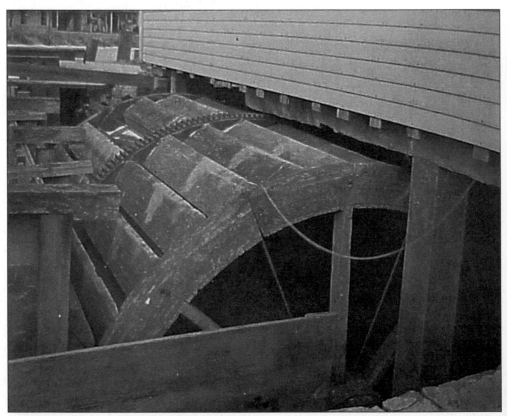

A CLOSEUP OF THE "OVERSHOT" WATER WHEEL. A wheel such as this was used in all three Gates' Mills. The water from the flume fell into the pockets, turning the wheel by its weight.

Toys and Tools Used Over One Hundred Years Ago in the Spinning Room and the Kitchen. The spinning room has two different-sized spinning wheels: the large one for flax and the smaller one for wool.

THE GATES MILL FLOOD

Early on April 5, 1913, villagers were awakened by the sounds of rushing water. During the night the Chagrin River had risen so high that by 6 a.m. people were rowing up the Main Street in Gates Mills.

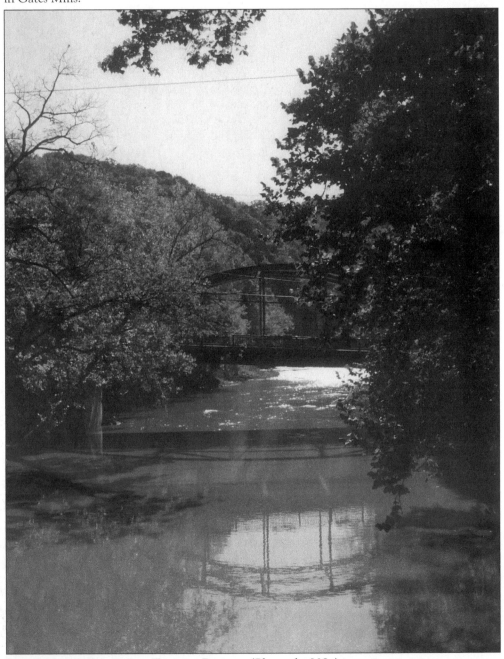

THE CHAGRIN RIVER AND TRESTLE BRIDGE. (Photos by V.L.)

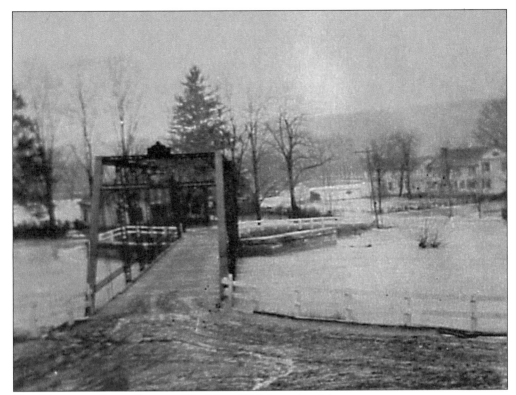

THE MAYFIELD ROAD BRIDGE. The Hunt Club is to the right.

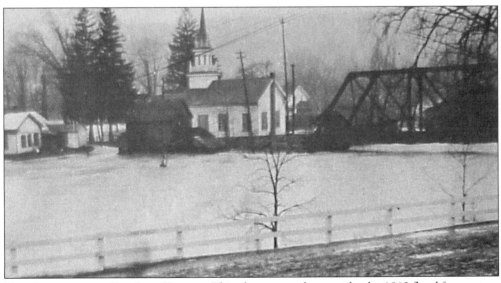

THE CHURCH AND CAR LINE BRIDGE. This photo was taken amidst the 1913 flood from across the river.

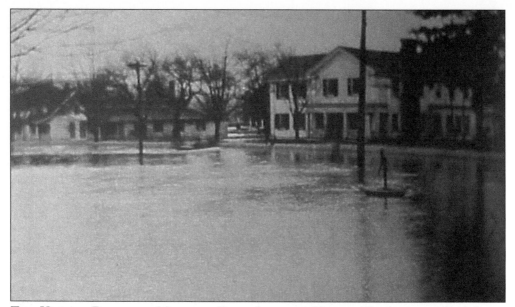

THE VILLAGE PUMP AND MAYFIELD ROAD LOOKING NORTH. The house to the left was Hunscher's, while the one on the right belonged to the Wrights. The pump is now the site of the Historical Museum. (All flood photos courtesy of Gates Mills Historical Society.)

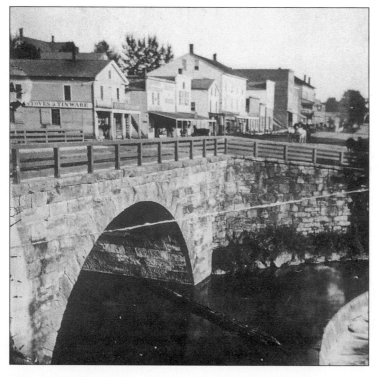

GENERAL STREET VIEW OF THE CHAGRIN FALLS, 1800s. (Photo courtesy of Cleveland Public Library.)

THE CHAGRIN RIVER LOOKING FROM A BRIDGE IN 1870. (Photo courtesy of Cleveland Public Library Photograph Collection.)

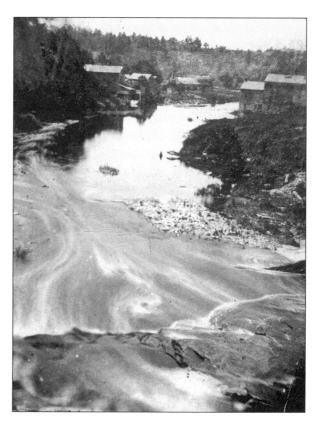

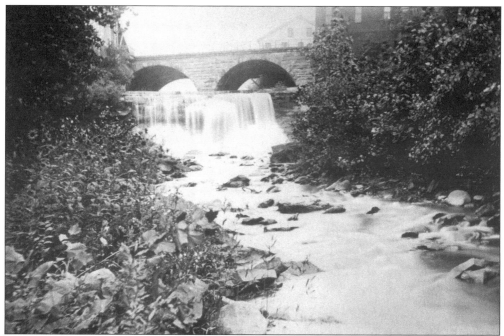

THE CHAGRIN FALLS OF THE CHAGRIN RIVER DURING THE 1913 FLOOD UNDER MAIN STREET. (Photo courtesy of Cleveland Public Library.)

THE CHAGRIN VALLEY HUNT CLUB

An opportunity has just now offered itself to secure six well-bred, well broken, fast, and good individual Fox Hounds, at the nominal price of $100. The first annual Horse Show was held in 1909 and has been continued regularly since. Soon after the purchase of the Inn, one of the stables was built, and then shortly after a second one. Meanwhile as more men and women began hunting, rooms at the Club were in demand over the weekends, and almost every bed was occupied. More trails through woods and fields were opened for riding and the Club was popular through the spring and early summer as well as in the hunting season which extended, as now, from August to the beginning of real winter.

(This is an excerpt of a letter written by M.C. Harvey in his recollections of soliciting members for the Hunt Club.)

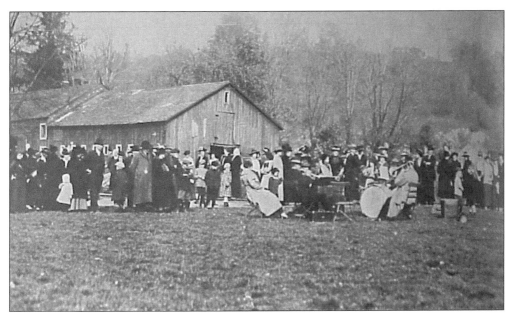

FARMER'S DAY AT THE CHAGRIN VALLEY HUNT CLUB, OCTOBER 28, 1916.

FOX HUNTING. In 1912, polo became one of the major activities of the Chagrin Valley Hunt Club, filling in the summer months which were usually called the "dull season" for the Club's original equestrian activity, fox hunting. By 1932, the Hunting Valley Field was opened, making possible the accommodations of constantly growing attendance at the Sunday afternoon games.

In 1931, the Chagrin Valley Hunt Club continued up the hill on Willey Road, in Geauga County. The huntsman was Jack Smith. (Photos courtesy of Gates Mills Historical Society.)

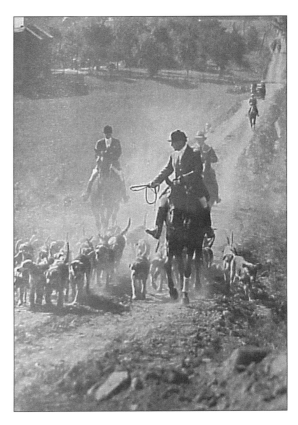

ORIGINAL HOLSEY GATES HOME. It later became the Maple Leaf Inn and the Chagrin Valley Hunt Club. (Photo courtesy of Gates Mills Historical Society.)

THE CHAGRIN VALLEY HUNT CLUB, GATES MILLS, OHIO, 2000. (Photo by V.L.)

Four
THOSE
LEGENDARY VANS

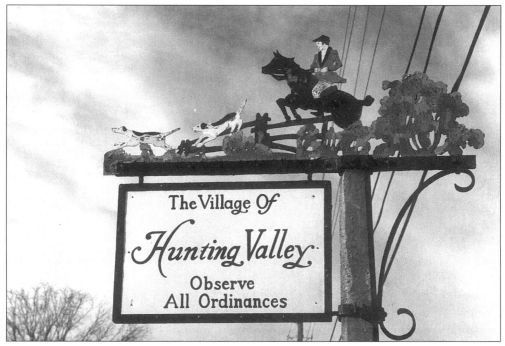

Photo by V.L.

The lives of Oris Paxton Van Sweringen and Mantis James Van Sweringen are deeply interwoven with the history of Orange Township. In 1822, the North Union Society of the Millennium Church of United Believers—also known as The United Society of Believers in the First and Second Appearance of Christ, and better known as the Shakers—had established a colony on the property of a Western Reserve land grant. One member of the sect had received the property through an inheritance. The Shakers became known as the largest celibate, communal, utopian society in America. The society had begun in the 18th century when a 38-year-old imprisoned working-class Englishwoman named Ann Lee, who could neither read nor write, claimed to have received a vision from God. In that vision, God had a chosen people in America.

Ann Lee set sail from England, along with eight followers, to New York. Her life was tragic from the beginning. Mother Ann, as she became known, had four children, all of whom had died by the time she was 30. Her husband left her because of her unswerving commitment to celibacy. Eventually more than 6,000 brothers and sisters of the sect established societies that thrived, until, at last, all but a few of the members and families died out.

It was in the Shaker Lakes area that the Shaker community thrived. The lakes powered their sawmill, gristmill, and woolen mill. At its peak, there were 300 members. By 1888, elder James Prescott, the head of the North Union division, died and the colony was disbanded. The remaining members moved on to other colonies.

In 1892, three years after the North Union Colony had been dissolved, a group of Clevelanders purchased the properties, which became known as Shaker Heights. The financial depression of 1890 did not mean success for the landholders. A Buffalo syndicate had bought the Shaker properties for $316,000, but by 1905 the value had fallen to $240,000.

Meanwhile, Lake Erie access encouraged the influx of immigrants moving into the city. At this point, wealthy Clevelanders fled the area to seek new land suitable for what was then called "high quality residential living."

THE DAISY HILL FARMS RESIDENCE, AUGUST 7, 1940. (Photo courtesy of Cleveland Public Library Photograph Collection.)

THE DAISY HILL FARMS RESIDENCE, 1940. (Courtesy of Cleveland Public Library Photograph Collection.)

Oris Paxton and Mantis James Van Sweringen were born in a farming area near Wooster, Ohio. Later they lived with their parents in Geneva, Ohio, before they moved to Cleveland. Their formal education ended at eighth grade.

They became successful in real estate. The Van Sweringens had become successful along with a syndicate of Cleveland businessmen. They decided to buy the entire 1,200 acres still held by the Buffalo-based company. The Vans' first company issued deed restrictions to be imposed for 99 years to ensure against what they called the encroachment of "undesirable" residents and improvements which they believed would depreciate the value of Shaker residential property.

THE DAISY HILL FARMS GREENHOUSES.

ORIS PAXTON'S BEDROOM. This room, in the Van Sweringen residence, is pictured after Mantis James Van Sweringen's death on February 10, 1937. (Courtesy of Cleveland Public Library Photograph Collection.)

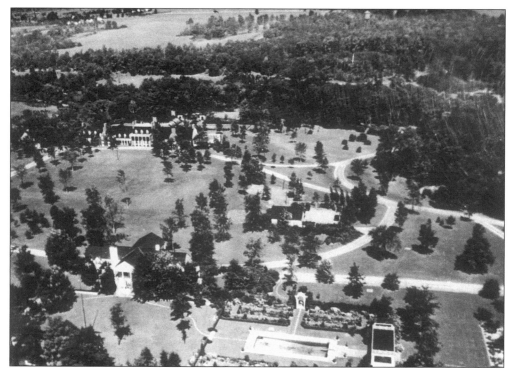

AERIAL PHOTOGRAPH OF RESIDENCES OF THE DAISY HILL FARM, PART OF THE VAN SWERINGEN ESTATE. This photograph was taken in 1940.

AN ARCHED STONE BRIDGE OVER A QUIET STREAM AT DAISY HILL FARM. A tower, like those of old Normandy, stands guard over the bridge. (Courtesy of Cleveland Public Library Photograph Collection.)

Against the backdrop of World War I, the Vans set their sights on Orange Township and began buying up farms. Because it meant much-needed cash, some farmers were delighted to be selling the land they had toiled upon for nearly two decades. Many other farmers, however, felt they were forced against their will to part with their land and homes.

The prices paid by the Van Sweringens ranged from $500 an acre and up, and, as they continued to buy, the values began to increase. Their original aim was to acquire a one-mile square property bounded on the south by North Woodland Road, on the east by S.O.M. Center Road, on the north by Shaker Boulevard, and on the west by Lander Road. Their country farm was called Daisy Hill, a 660-acre property managed by Ben and Daisy Jenks. Later, a portion of the property became the 54-room Roundwood Manor that the Vans called home, and that is today called Daisy Hill.

When the huge homesite area opened, the new Van Sweringen development involved four thousand acres of land, opening wide the district under their control. The two brothers had vast plans for roadways and large blocks of homes, with 5- to 10-acre parcels available. They even planned for the right of way of rapid transit extension when they felt such service was justified.

A HERD OF THOROUGHBRED CATTLE ON A PART OF THE VAN SWERINGEN ESTATE.

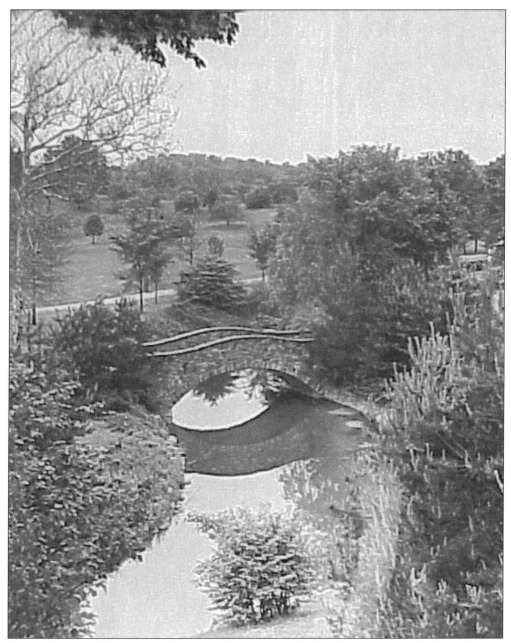

STONE BRIDGE. This stone bridge extends over a brook that flows through the farm. Next is the entrance to the cottages of the paddock group, where families lived. This is one of the many bridges over the brook and a section of the landscaped countryside on the Van Sweringen estate.

COUNTRY SCENE. This is one of the many beautiful stretches of territory included in the 4,000-acre development from Green Road to the Chagrin River announced by members of the Van

Sweringen Company. (Photo courtesy of Cleveland Library Photography Collection.)

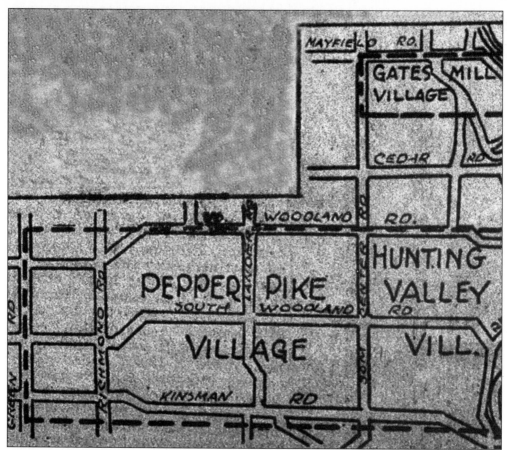

MAP OF ORANGE TOWNSHIP. The boundaries of the development are roughly outlined in this map, including the holdings to be developed in and about Gates Mills. The Van Sweringens did not own all of the land shown on this map. (Courtesy of Pepper Pike Archives.)

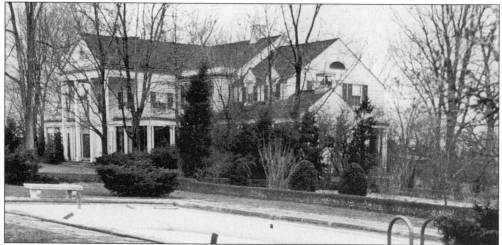

THE BEN JENKS RESIDENCE ON THE VAN SWERINGEN ESTATE, FEBRUARY 10, 1937. (Photo courtesy of Cleveland Public Library Photographic Collection.)

A House and Car on the Van Sweringen Estate. (Photo courtesy of Cleveland Public Library.)

Electric interurban lines built in eastern Cuyahoga County and Geauga County in the late 1890s made travel feasible to downtown Cleveland for residents of Chardon, Middlefield, Gates Mills, Chagrin Falls, and the rural areas in between. A 1 or 2-hour ride to the city seemed a marvel to travelers who had no previous means of transportation other than horse and wagon. But with the coming of automobile ownership in large numbers after World War I and the paving of rural highways, the days of the interurbans were already numbered.

As this was happening, the Van Sweringen brothers were planning a county-wide rapid-transit network. As early as 1909, the Vans had envisioned a rail hub on Public Square in Cleveland for both inter-city steam trains and electric interurban lines. They had to solve the problem of transportation if their suburban real estate venture was to succeed.

Entering into an agreement with the Cleveland Railway Company, they constructed their first rail line. Operation began in early 1913. From Fontenay Road the trolleys headed west to Coventry Road, and north on Coventry to Fairmount Boulevard where they joined the tracks of Cleveland Railway's Fairmount line. They then headed west on Fairmount to Cedar, and on down to University Circle and Euclid Avenue for the trip downtown.

An expanded Shaker Boulevard line was also contemplated at the time. Grading was extended on the Shaker line all the way to Brainard Circle, then out Gates Mills Boulevard almost to Mayfield Road. Original plans called for the Shaker line to split at Brainard Circle. One branch would continue out Gates Mills Boulevard to hook up with the abandoned Eastern Ohio interurban line to the village of Gates Mills. Another branch would veer off to the southeast across the county to connect with the tracks of the former Eastern Ohio interurban line to Chagrin Falls.

Today the grading can still be seen in the median of Shaker Boulevard at Richmond Road and in the median of Gates Mills Boulevard.

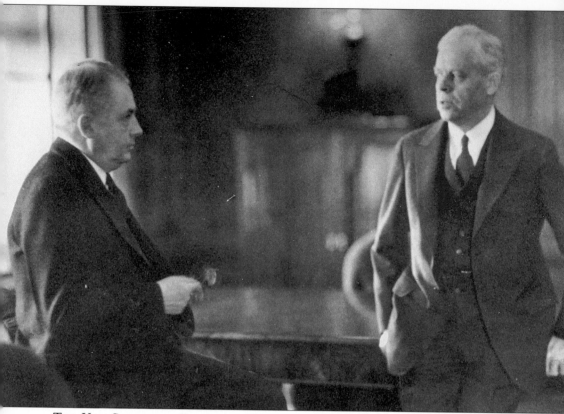

THE VAN SWERINGEN BROTHERS. Their eventual holdings were at one time valued at $3 billion. When the stock market collapsed in 1929, they were ruined.(Photo courtesy of Cleveland Public Library Photographic Collection.)

To satisfy creditors, the furnishings of the two Van Sweringen brothers' Daisy Hill Farm were sold at a public sale October 25, 1938. The two brothers started from nothing, pyramided their holdings to $3,171,000,000, and lived to see the crash of their empire but not the sale of their personal possessions. The Van Sweringens controlled one of the largest American railroad empires. O.P. Van Sweringen pleaded not guilty to an indictment charging he aided the issuance of a false financial statement for the closed Union Trust Company.

Daisy Hill was not a farm, but more like an English feudal estate with more than 500 acres of park and 15 stately houses scattered among the trees and lawns. More than 3,000 items went under the auctioneer's hammer. Their bed was from the home of John Quincy Adams, early American president, and the other items in the rooms were connected to him as well.

By 1938, the Van Sweringen brothers had filed in Federal Court under Section 77-B of the Bankruptcy Act. Jones, Day, Cockley, & Reavis, and Fackler & Dye were the Van Sweringen company attorneys. The deeding of the 206 acres and the colonial clubhouse of the Country Club property (on Lander Road in Pepper Pike) by the Van Sweringen Company to the Cleveland Terminal Buildings Company relieved the Van Sweringen Company of more than $1 million worth of debt.

The deeding of the property, in return for a release from the obligation of the guaranty on the notes, was approved by Federal Court. In addition, the Van Sweringen Company transferred back to former owners a number of farms beyond Green Road, thus relieving the company of further large sums in liability.

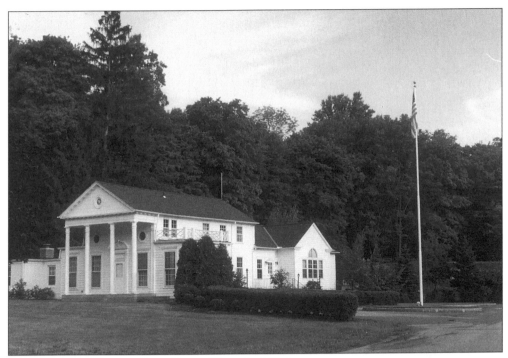

The Hunting Valley City Hall. (Photo by V.L.)

Village Scene in Hunting Valley. (Photo by V.L.)

EARLY MORNING IN THE VALLEY. (Photo by V.L.)

Enter Hunting Valley, an 11-square-mile residential village along the Chagrin River and bordered by Gates Mills, Moreland Hills, Woodmere, and Pepper Pike. It is the setting today of private estates, farm acreage, and luxurious country homes.

Hunting Valley, originally a part of Orange Township, was incorporated as a village in 1924. It was settled in 1815 and established in 1820. Wealthy industrialist Jeptha Homer Wade II bought 455 acres for his summer estate in Hunting Valley. The 80-room mansion was completed in 1909, and the estate was called Valley Ridge Farm. The mansion was completely destroyed by fire in the 1920s. It was later owned by Andrew Squire who bequeathed it to Western Reserve University.

THE FORMER VAN SWERINGEN ESTATE IN HUNTING VALLEY. (Photos by V.L.)

ROUNDWOOD MANOR, OF THE VAN SWERINGEN ESTATE.

FORMER CLEVELAND-GATES MILLS-CHARDON INTERURBAN LINE PATH NORTHSIDE OF BERKSHIRE ROAD NEAR WOODSTOCK ROAD, LOOKING WEST, GATES MILLS, OH.

Described by Louis B. Seltzer in his autobiography, the Van Sweringens shared a dream of beautiful suburbs that surrounded a remodeled city. They were legendary figures at a time when the country needed all who had a vision and the determination to see it through. Oris and Mantis Van Sweringens' Daisy Hill Farms in Hunting Valley were bought in 1920. After their deaths the property was sold and divided into more than 60 private estates. By 1950 the population of Hunting Valley was 447.

Six
THE INTERURBANS
THE RAILROAD COMES TO TOWN

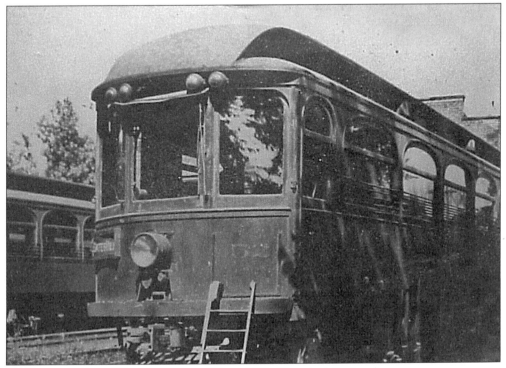

INTERURBAN CAR. (Photo courtesy of Gates Mills Historical Society.)

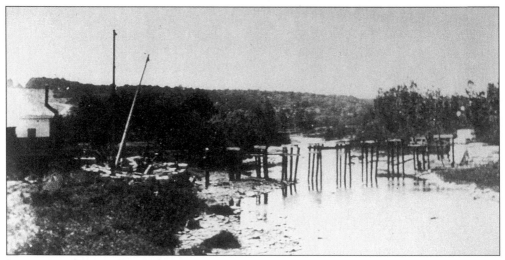

BUILDING A BRIDGE FOR TRACTION TRACKS IN 1898. West Hill Road is in the background. (Photo courtesy of Gates Mills Historical Society.)

A CURRENT PHOTOGRAPH OF THE TRESTLE BRIDGE. (Photo by V.L.)

The following writing was compiled by Abigail B. Fleming, historian, and the Gates Mills Community Club:

ACQUIRING THE RIGHT OF WAY
FROM THE WRITINGS OF HARRISON B. MCGRAW
HISTORICAL SKETCHES OF THE VILLAGE OF GATES MILLS
COURTESY OF THE GATES MILLS COMMUNITY CLUB AND THE GATES MILLS HISTORICAL SOCIETY

In or about 1899, I was associated with a group of men who were building an electric railroad extending from the corner of Mayfield and Taylor Roads in an easterly direction along Mayfield Road and beyond to the villages of Chardon and Burton located in Geauga County, Ohio.

Early in the days of the enterprise it became apparent to the promoters that the plan of using steam power was not feasible and it also became apparent that a private right-of-way, instead of a public right-of-way, would be most desirable…

At the time the enterprise was under way, it was almost impossible to cross the Gates Mills Valley in the winter and spring until the roads dried out, for until they did dry out the valley was, so far as roads were concerned, a quagmire and almost impassable to horses and wagons. Traffic in winter and spring was so difficult that Geauga County was sending its produce south to the Pittsburgh markets and using the Baltimore & Ohio Railroad to do so. At the time, the automobile was not far enough developed, nor were the roads good enough for their use.

During the course of the taking of the right-of-way I, myself, purchased at $75 per acre, a 50-acre farm owned by a man named Petranek, which later I sold to Frank H. Ginn and which forms the principal part of the site of his residence which he and Mrs. Ginn named 'Moxahala.'

In the course of taking the right-of-way, it further became evident that the railroad, in order to cross the Gates Mills ravine, would have to take a circuitous route through the valley in order to get up the hill on the easterly side. Therefore, a private right-of-way was located at a point westerly from the Petranek farm. It turned rather sharply to the south in order to get down the hill. In order to get down the hill and cross the river it was necessary to take a large piece of the farm of Dallas Dean, whose residence was the farmhouse now constituting part of the Chagrin Valley Hunt Club clubhouse. Dean did not look with any favor upon selling the right-of-way at a small price per acre. He held off from closing a bargain with us until his was about the last piece of right-of-way.

We did not wish to condemn it because we were afraid that the jury would name a large price. We made such frequent efforts to negotiate with Dean that one day he saw me coming and went into the house and brought out a shotgun and aimed it at me from the porch. I discontinued negotiations at once and made up my mind that we would have to condemn. A week or ten days later I happened to be going through the valley and passed Dan's farmhouse. He came out on the porch and asked me to come in. He told me that I was the only lawyer that he knew, and that he wished me to defend Mrs. Dean in a suit brought by a Chicago piano house against her for deferred payments on a contract for the purchase of a piano. Dean said that she had purchased the piano against his wishes and that when the payments had become due he had not let her make payments on them. The Chicago piano house had brought suit against Mrs. Dean in the Justice Court which Henry Russell ran in his farmhouse at the southwest corner of Mayfield and SOM Center Roads at the top of the hill on the west side of the Gates Mills ravine. I at once accepted the employment and succeeded in winning the case. I do not remember whether the defense was meritorious or not, but I do know that everyone in Mayfield Township, including the Justice of the Peace, knew about Dean's shotgun and how apt he was to use it if irritated. This, I think produced a favorable atmosphere for my side of the case. When the case was over and victory was assured, I received a deed of the right-of way for my fee.

The above constitutes about the only memory that I have of Gates Mills which might be of interest for your historical collection. I might say, however, that my recollection is that the original name, instead of being 'Gates Mills,' was 'Gates Mill.' Some of the present residents of the Village have disputed that fact but I still adhere to my recollection.

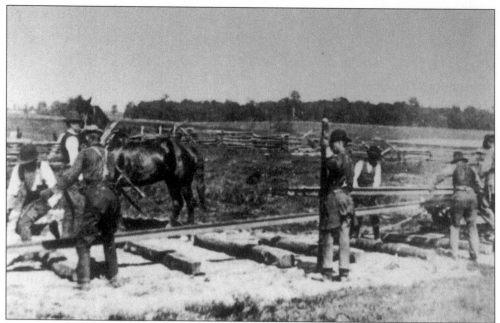

LAYING TIES AND STACK BY HAND AND HORSE, 1898. A rail fence encloses a farm in the background. (Photo courtesy of Gates Mills Historical Society.)

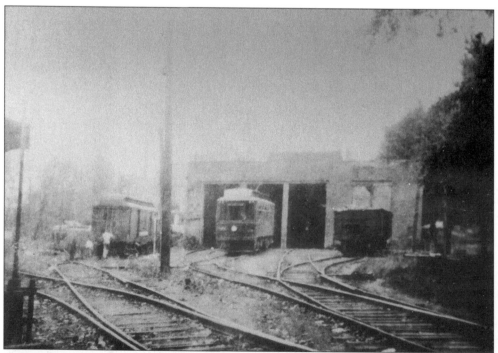

CAR BARNS, 1910. These barns were part of the Cleveland Eastern Traction Company. This area would later become the village green of the Gates Mills Town Hall in 1956. (Photo courtesy of Gates Mills Historical Society.)

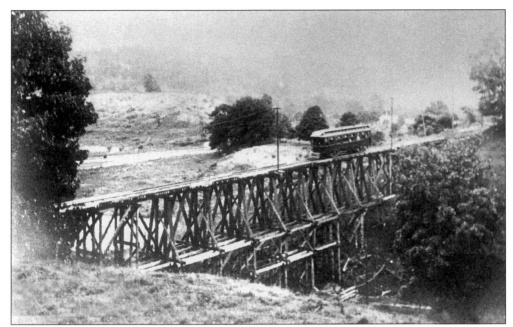

CAR ON TRESTLE, 1907. This car is starting a downgrade of the hill behind Burtons. Epping Road is below the river and beyond the east hill.

CAR STOP #20. (Photos courtesy of Gates Mills Historical Society.)

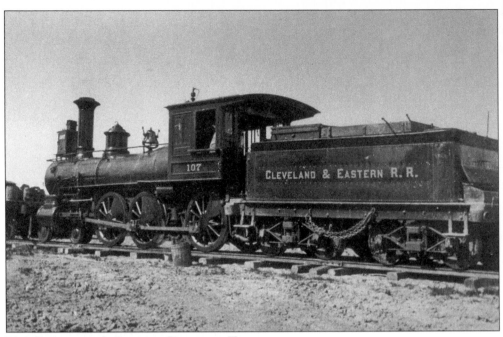

THE CLEVELAND & EASTERN RAILROAD TRAIN.

WORKMEN IN FRONT OF POWERHOUSE OF THE CLEVELAND EASTERN TRACTION COMPANY.
(Photos courtesy of Gates Mills Historical Society.)

From the Writings of J.N. Fleming
Plank Road and Surburban Car Days
Historical Sketches of the Village of Gates Mills
Courtesy of Gates Mills Historical Society

For a number of years we had a summer cottage in the beautiful Cuyahoga River valley alongside the old Ohio Canal. Those were horse and buggy days. We arose at five in the morning and had long drives about that fine countryside before breakfast, then took the Baltimore and Ohio local train to business in the city. We were thus established in a love for the hills and valleys, the woods and streams.

We had heard of the glories of Gates Mills, so in the Spring of 1906 we rode out one day on the Cleveland and Eastern Electric Line, and were captivated by the beauties of the springtime out there. We met Mr. Frank Ginn, and rented from him a little white cottage which then stood opposite the neat station, called "Stop 20." We thus became commuters on the electric line. One of the recollections of that service is the "Bankers Limited," as the Cleveland Press called the special car which ran morning and evening for the businessmen of the Village. Monthly tickets were sold at a slight premium for the rides on this "Limited." All the members of the family were privileged to ride on it, but were required to hold up a yellow ticket as they stood at an uptown corner after shopping, otherwise the motorman would not stop. A very friendly and jolly group of businessmen rode in each morning. The morning papers came out on an early car, and were available to those who wished to read, but most of them chatted and debated how those at Washington should act.

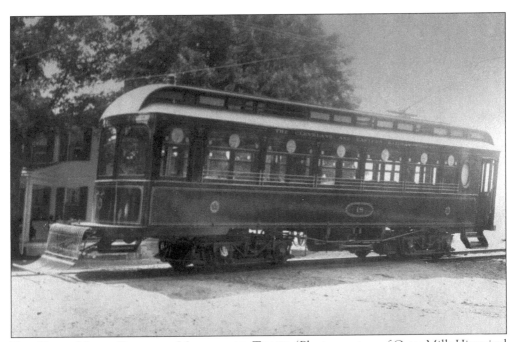

The Gates Mills–Chardon–Middlefield Train. (Photo courtesy of Gates Mills Historical Society.)

THE CLEVELAND AND EASTERN RAILWAY
FROM THE WRITINGS OF O.F. GARY
COURTESY OF GATES MILLS HISTORICAL SOCIETY
HISTORICAL SKETCHES OF THE VILLAGE OF GATES MILLS

The Cleveland and Eastern Railway, Maple Leaf Route, was financed by a group of about twenty prominent Cleveland men among whom were H. Clark Ford and Charles Ranney, and cost about $1,500,000. The road extended to Chardon, thirty miles east of Cleveland. . . . Later a fourteen-mile spur was built to reach Burton and Middlefield. . . . Right-of-way along the eastern edge of the Methodist Church property (now St. Christopher's) was purchased with the building of church sheds and the installation of a steeple bell.

Surveying was begun in the spring of 1898; grading was started during that summer; and track laying was started at Chardon in the spring of 1899. Work on the eastern end was rushed in order to provide track for the supply trains bringing material for the building of a powerhouse and car barns at Gates Mills, and the trestle across the ravine that runs near Glen Echo Road was built. In the fall of 1899, service was started with a passenger coach rented from the Lake Shore and Michigan Southern Railway and drawn by a locomotive belonging to the Nickel Plate Railway. This train made two trips daily and connected with a shuttle trolley that ran between Stop 18 (now SOM) and Lee Road.

The first electric car to make the trip the length of the road made that run on January 1, 1900, and took the greater part of the day, due to slippery track, failure of power and what not.

There were numerous wrecks. Among the outstanding were the overturning of a car of coal on the east hill, burying two men; and a car of ninety passengers, most of whom had been blackberrying, tipped over in the "Jungle" near Fullertown. Cars sometimes ran away down the hills and swept through the car barns or around the sharp curves at the foot of the west hill, bearing a white-faced crew and shaken passengers. Several times autos drove onto the tracks in front of the great speeding trolleys and the results were usually pretty tragic. One case in particular was that of the young conductor, Johnny Novak, who drove along beside a car, waving to the crew, and absentmindedly turned into the drive of his sweetheart's home, in front of the oncoming car.

Weather often caused a great deal of trouble. Early in the history of the road a late April snow fell so heavily that it was impossible to run cars at all east of Gates Mills. In spite of General Manager Andrew's determination to "keep the road open to the west" the car leaving Gates Mills at nine that morning did not reach Cleveland till six o'clock that night, and one car spent the day at Stop 18. During the flood of the spring of 1913 cars were at a standstill for several days and water ran into the powerhouse, putting out the fires.

"During the year 1920, the road carried over a million passengers and stock paid a dividend of one-half of one per cent, the only dividend ever paid.

"With the growing popularity of automobiles, trucks, and the installation of bus service on Mayfield Road, the trolley line rapidly failed. Facing a continuing loss it appealed to the State Utilities Commission for permission to disband.

On July 1, 1924 service ceased, but due to some rule of the Commission, it was compelled to resume after a few hours and continued for some months. The last car ran from Cleveland to Gates Mills, having left the Square at 11:15 P.M. on March 31, 1925.

The Road was salvaged at once and the old right-of-way through Gates Mills is now a bridle path.

Seven

A LIFE IN PICTURES

GATES MILLS'
TUCKER-MARSTON FAMILIES

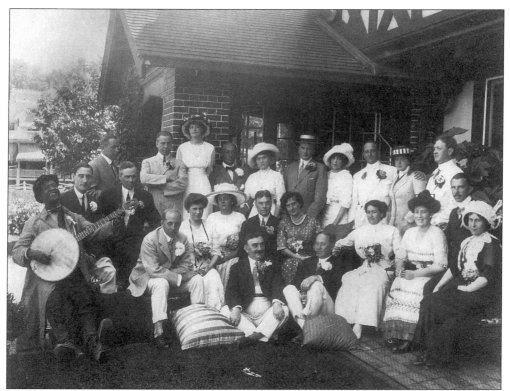

ENGAGEMENT PARTY. Mrs. Connie Novello, whose family appears on the cover of this book, is the daughter of the late John Mitchell Marston, who was mayor of Gates Mills for 18 years. Mrs. Novello has supplied the story of her family beginning on page 99.

This is a garden party in the early 1900s. It is the engagement party for Charles Harbaugh and Lucy Tucker. The guests were the children of Charles Tucker and their cousins. The name of the banjo player is unknown.

Bartow Tucker, Gertrude Kefaber Tucker, and Martha Tucker.

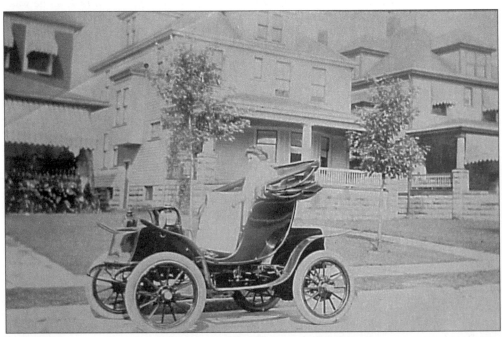

Lucy Wightman Tucker in Front of Her House in Cleveland.

CONSTANCE TUCKER MARSTON HOLDING
CONNIE MARSTON NOVELLO.

John Mitchell Marston was mayor of Gates Mills for 18 years. From 1930 to 1933 he was a member of the 107th Cavalry in the Ohio National Guard. He was a major in the Air Force from 1942 to 1946. John's father, Charles Marston, and his family immigrated from Ireland.

"The earliest members of my family can be traced to the 1500s. Edward Wightman lived in Lichfield, England. He married Frances Darbye in 1593 and they had five sons. Edward apparently disagreed with the church on some matter. He was put to trial there in Lichfield Cathedral, for having argued with the bishops, and was sentenced to death. He was burned at the stake for heresy on April 11, 1612. He was the last person in England to be put to death by this method for religious reasons. There is a bronze plaque on the town square to this day commemorating this event. His property and assets were confiscated by the church. Most of his five sons are thought to have emigrated to Rhode Island.

"Later the sons married and raised families. John stayed in England. His son, George, came to America as a young man and married Elizabeth Updike. Their son, Valentine, married Suzanna Holmes in 1703 and raised a family of nine children, two of whom became Baptist ministers. One of Valentine's sons later married and fathered a son, Timothy, who fathered a son named John. John married Calista Morgan and lived in Groton, Connecticut.

"Later another Morgan son, James, fathered a son, William, who became a captain in the Revolutionary War. William married Temperance Avery and they had a son named Christopher Columbus. Christopher married Deborah Ledyard, and their daughter, Deborah Calistra Morgan, married John Wightman.

"In 1811, the Morgans, along with the Wightmans, came to Newburgh, Ohio, now a suburb of Cleveland. The Ledyard family was one of the most prominent in Connecticut. Colonel Ledyard was a leader of the American forces at the battle of Groton Heights and was killed by the British."

MARTHA TUCKER WITH BABY GERTRUDE
TUCKER.

CONSTANCE TUCKER ON HER HORSE.

BABY TUCKER WITH HER NANNY.

BABY TUCKER AND HER NANNY ON AN
OUTING.

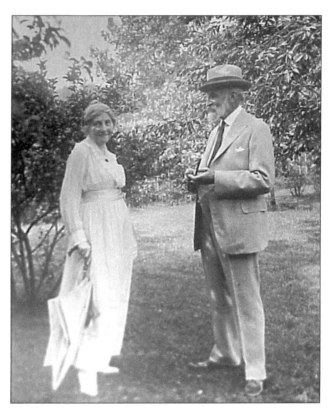

CHARLES AND LUCY TUCKER.

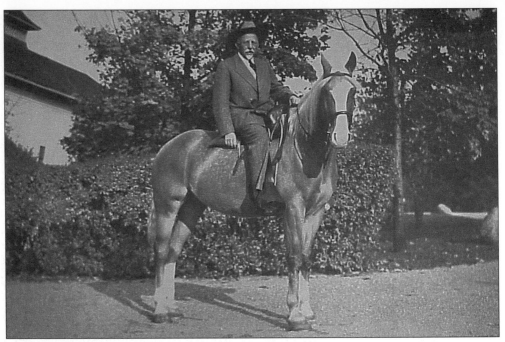

STAN TUCKER AT HIS FARM.

"Records show that when John J. and his wife left Groton, they traveled by ox team. The probable route they took was to the Hudson River, then west through the Mohawk Valley to Buffalo. If they traveled in the winter, they would follow the lake shore. Here they could follow the ice and make good time. Or, if there was no ice, they would have taken a large, open boat and followed close to shore, going ashore at night to sleep. When they got to Newburgh, John bought ten acres of land on the west side of Woodland Hills Road for $60.00. The date of this purchase was June 22, 1811. Somewhere on this property was the Wightman Tavern. In 1827, Wightman acquired by trade some land on Broadway. It is believed this property was on both sides of the road, west of what is now East 55th Street.

"In Newburgh, John and Deborah had a son, David Long. In 1839 David married Adaline Maria Johns(t)on. He was sheriff of Cuyahoga City (forerunner of Cleveland) in 1859. During the Civil War, he was a U.S. Marshall in this area. In 1872, David was the first agent of the Humane Society. He organized 'Wightman's Infant Rest,' the first of its kind in Cleveland. Babies were always being left on doorsteps, and the organization was a necessity. David and Adaline had a daughter in 1844 named Lucy Adaline. My sister is named for her. Lucy Adaline married Charles Herbert Tucker in 1868. I get my name from his mother, Susan Bartow (of French Huguenot ancestry from Tarrytown, New York.) Charles' father, George Washington Tucker, was the first white child to be born in the Erie

102

Marriage License, 1862. (Photo courtesy of Connie Novello-Marston family archives.)

County Reservation in New York in a town named N. Collins. The reservation was Iroquois Indian and this was in 1810.

"Lucy and Charles had four sons and two daughters. The younger daughter, Lucia Heppe, after whom my mother is named, was my great-grandmother. She was born May 23, 1875 and died December 1956.

"Charles Herbert Tucker was a 33-degree Mason, the highest order in Masonry. At the wedding of Mark Hanna, Charles was the best man. John D. Rockefeller was an usher in the same wedding party. They were all young men in the same "crowd." Mr. Rockefeller wanted Charles to go into the oil business with him, but even then he was skeptical of John D.'s business practices and would not. Charles was in the steamship business for many years as an agent for many different lines.

"Lucia Heppe married Charles Reiber Harbaugh and they had two children, Donald and Virginia Valmi, my great-uncle and grandmother. The Harbaugh lineage goes back to before 1736, when Yost Harbaugh, who was born in Switzerland, came to America. He settled first in Masatourey, a valley in Berke County between Reading and Allentown, Pennsylvania. One of their descendents, Jacob Reiber, was proprietor of the Cleveland Hotel from 1858–1877. This was the largest and finest hotel in the city. The Reiber family had come from Goeninger, Germany."

ABBY, LUCIA, RALPH, AND SALOME TUCKER. (Photos courtesy of Novello-Marston family archives.)

CONNIE'S MOTHER, LUCY, AND LUCIA IN THE FRONT YARD OF THEIR LOGAN AVENUE HOME.

GERTRUDE KEFABER TUCKER, WIFE OF BARTOW.

"Salome Tucker was born January 7, 1872, the second oldest of six children. She lived at 846 Logan Avenue where the Cleveland Clinic complex now stands. She attended Bolton School and later Hathaway Brown School. During summer vacations, she often accompanied her father on steamer trips on all the Great Lakes. Her brother, Bart, married Gertrude Kefaber and they had two daughters: Martha was born in 1904, and Constance in 1907. In 1914, Gertrude died as a result of complications during surgery. Salome moved in and helped raise both girls. They spent many happy hours at Uncle Stan Tucker's farm in Willoughby, milking cows and riding horses. He had a large garden and grew everything, including melons."

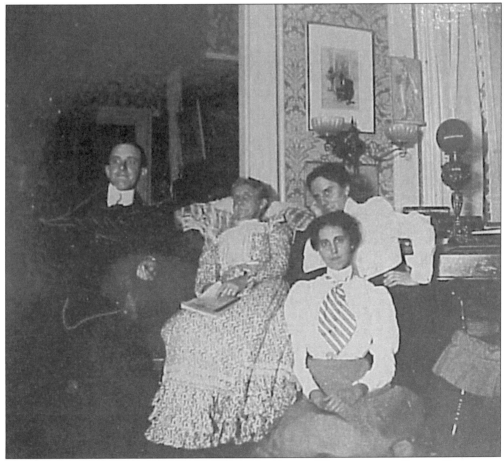

CONNIE NOVELLO'S MOTHER, BART, SALOME, AND LOUISE WRIGHT IN THE LIVING ROOM AND LIBRARY OF THEIR LOGAN AVENUE HOME.

Tucker Children and Their Grandparents.
(Photos courtesy of Novello-Marston family archives.

TUCKER FAMILY CHILDREN.

MARTHA AND CONSTANCE (BUNNY) TUCKER.

RALPH TUCKER.

TUCKER
CHILDREN
AND A
GRANDPARENT.

CONSTANCE HELENE TUCKER AND JOHN MARSTON. "Constance Helene Tucker was born July 11, 1907. She was the daughter of Bartow and Gertrude Tucker. She graduated from Hathaway Brown School in 1925, and then attended Pine Manor Finishing School in Vermont. In 1930 she went to a dance and met John Marston. They were married April 17, 1931, and, because of the Depression, they moved into Grandma Mitchell's house on 97th Street. In 1934 they moved to Gates Mills. They had three children—Connie, J. Tucker, and Charles—and six grandchildren."

(Tucker family photos and quote courtesy of Mrs. Connie Novello and the Tucker-Marston family archives.)

LATE PRESIDENT RICHARD MILHOUSE NIXON AND MAYOR JOHN MARSTON OF GATES MILLS IN FRONT OF THE GATES MILLS VILLAGE HALL.

Eight

THE YEARS THAT CHANGED THE WORLD

The soul of man is like the rolling world,
One half in day, the other dipt in night;
The one has music and the flying cloud,
The other, silence and the wakeful stars.

–A. Smith (1830–1867.)

Photo by V.L.

LETTERS FROM THE FRONT

MARIANAO, CUBA, VIA TAMPA, DECEMBER 15, 1898—*After eight days' travel we passed Moro Castle and entered the bay at Havana. We were impressed first by the strangeness of this picturesque country and its inhabitants; then by the very disagreeable odors that greeted our nostrils, similar in "bouquet" to the offensive gases given off from a city sewer. We passed the debris of the Main and anchored; then we were treated to a sight. Hundreds of boats surrounded the ship and the clatter of tongues informed us this or that particular boat was the only one good enough for us to land in, for you must know that we are not permitted to land direct from the ship, but must be transferred to large boats and rowed ashore, to the custom house, a distance of a mile or more, where Spanish officials inspected us and our baggage*

Chagrin Falls Exponent

MARIANAO, CUBA, DECEMBER 5—*This place is about eight miles west of Havana and is a summer resort. Our camp is on the hills back from the beach and is a very beautiful place. This is intended for a large military camp. Thousands of Spanish and Cuban soldiers are camped around us; the Spanish on our east, the Cuban army on the coast west of our camp. The Cubans are a poor, ragged set of men, but good-natured and willing to work. The Spanish soldiers are a clean set of intelligent men, very friendly, and do not seem to understand why we were at war with one another. Everywhere you will see Spanish officers...*

Chagrin Falls Exponent

Right: **WORLD WAR I IDENTIFICATION TAG OF JAMES RUDOLPH WILSON.**

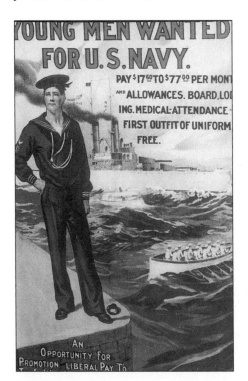

Left: **U.S. NAVY POSTER, 1800S.** Chagrin Falls boys served in Uncle Sam's Cuban Army and Navy, feeding starved Cubans who suffered from the ravages of war.

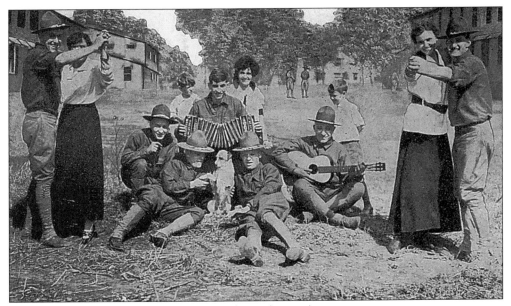

WORLD WAR I PHOTOGRAPH. (Photographer unknown.)

World War I. It was called the "The Great War," "The "Romantic War," "The War to End All Wars," "The Great Crusade," and "The Lost Generation." It was the year that changed the world. It was the year of the terrible freeze. It was, in all of its horrific destruction and loss of our boys' lives, a war that lasted a mere 18 months. The peace-making period is recorded as 1919 to 1920.

May, 1917—President Woodrow Wilson's address to the National Army:

You are undertaking a great duty. The heart of the whole country is with you. The eyes of all the world will be upon you., because you are in some special sense the soldiers of freedom. Let it be your pride, therefore, to show all men, everywhere, not only what good soldiers you are, but also what good men you are, keeping yourselves fit and straight in everything and pure and clean through and through. Let us set for ourselves a standard so high that it will be a glory to live up to it, and then let us live up to it and add a new laurel to the crown of America. My affectionate confidence goes with you in every battle and every test. God keep and guard you!

And so the horror began . . .

Over There/Over There/Send the word/Send the word/Over There/That the boys are coming/The boys are coming/The drums rum-tuming everywhere./Over There/Say a prayer/Send the word/Send the word/To Beware/It will all be over./We're coming over/And we won't come back/Till it's over/Over There . . .

George M. Cohan.

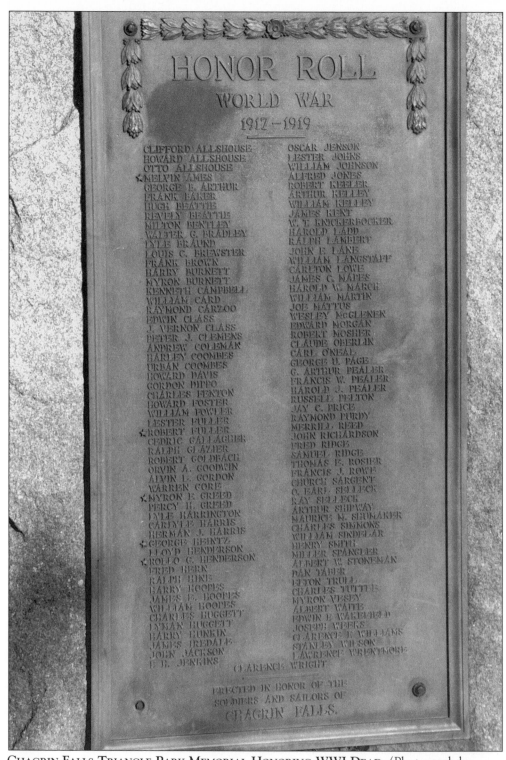

HONOR ROLL
WORLD WAR
1917–1919

CLIFFORD ALLSHOUSE	OSCAR JENSON
HOWARD ALLSHOUSE	LESTER JOHNS
OTTO ALLSHOUSE	WILLIAM JOHNSON
MELVIN AMES	ALFRED JONES
GEORGE E. ARTHUR	ROBERT KEELER
FRANK BAKER	ARTHUR KELLEY
HUGH BEATTIE	WILLIAM KELLEY
REVELY BEATTIE	JAMES KENT
MILTON BENTLEY	W. T. KNICKERBOCKER
WALTER G. BRADLEY	HAROLD LADD
LYLE BRAUND	RALPH LAMBERT
LOUIS C. BREWSTER	JOHN E. LANE
FRANK BROWN	WILLIAM LANGSTAFF
HARRY BURNETT	CARLTON LOWE
MYRON BURNETT	JAMES G. MAPES
KENNETH CAMPBELL	HAROLD W. MARCH
WILLIAM CARD	WILLIAM MARTIN
RAYMOND CARZOO	JOE MATTUS
EDWIN CLASS	WESLEY McCLENEN
J. VERNON CLASS	EDWARD MORGAN
PETER J. CLEMENS	ROBERT MOSHER
ANDREW COLEMAN	CLAUDE OBERLIN
BARLEY COOMBES	CARL O'NEAL
URBAN COOMBES	GEORGE U. PAGE
HOWARD DAVIS	G. ARTHUR PEALER
GORDON DIPPO	FRANCIS W. PEALER
CHARLES FENTON	HAROLD J. PEALER
HOWARD FOSTER	RUSSELL PELTON
WILLIAM FOWLER	JAY C. PRICE
LESTER FULLER	RAYMOND PURDY
ROBERT FULLER	MERRILL REED
CEDRIC GALLAGHER	JOHN RICHARDSON
RALPH GLAZIER	FRED RIDGE
ROBERT GOLDBACH	SAMUEL RIDGE
ORVIN A. GOODWIN	THOMAS E. ROSIER
ALVIN L. GORDON	FRANCIS J. ROWE
WARREN GORE	CHURCH SARGENT
MYRON E. GREED	O. EARL SELLECK
PERCY H. GREED	RAY SELLECK
LYLE HARRINGTON	ARTHUR SHIPWAY
CARLYLE HARRIS	MAURICE M. SHUMAKER
HERMAN J. HARRIS	CHARLES SIMMONS
GEORGE HEINTZ	WILLIAM SINDELAR
LLOYD HENDERSON	HENRY SMITH
ROLLO G. HENDERSON	MILLER SPANGLER
FRED HERR	ALBERT W. STONEMAN
RALPH HINE	DAN TABER
HARRY HOOPES	EFTON TRULL
JAMES E. HOOPES	CHARLES TUTTLE
WILLIAM HOOPES	MYRON VESEY
CHARLES HUGGETT	ALBERT WAITE
LYMAN HUGGETT	EDWIN E. WAKEFIELD
HARRY HUNKIN	JOSEPH WEEKS
JAMES IREDALE	CLARENCE E. WILLIAMS
JOHN JACKSON	STANLEY WILSON
E. B. JENKINS	LAWRENCE WRENTMORE

CLARENCE WRIGHT

ERECTED IN HONOR OF THE
SOLDIERS AND SAILORS OF
CHAGRIN FALLS.

CHAGRIN FALLS TRIANGLE PARK MEMORIAL HONORING WWI DEAD. (Photograph by V.L.)

When the guns of August ceased, close to 9 million men had died, from the beginning of combat in 1914 until the signing of the Armistice that ended World War I on November 11, 1918.

From the *Chagrin Falls Exponent* in 1917, there were headline stories and there were letters. The following excerpt depicts the scene as young men went off to France:

> *The first to start for the battlefields from this section (Chagrin Falls) are not soldier boys, but young women. With the Lakeside Hospital unit that left Cleveland, Sunday to embark at an eastern port this week were Miss Anna Carlton, formerly of Chagrin Falls, and Miss Isabel Bishop, formerly of Solon. Both are Red Cross nurses. From Chardon, Miss Mabel Allyn and Miss Elise Brower, and from Orange, Pomeroy and Thomas Fletcher went with the unit.*
>
> *Chagrin Falls boys are helping to swell the ranks of Uncle Sam's army. Earl Hoopes, son of B.R. Hoopes, last week joined the Third Ohio regiment and left Monday night to join his regiment in southern Ohio. He goes to Co. F., the same company in which his brother, William, is now serving. Another brother, Earl has passed the examination for entrance to the Officers Reserve Corps and awaits call for service.*
>
> *Chagrin Falls Exponent, summer 1918*

A **Bronze Soldier.** This bronze statue stands at the entrance to the Ohio Veteran's Home in Sandusky, Ohio. (Statue in bronze by Larry Anderson; photo by V.L.)

World War I

Hope you have received my several letters all right, for I know how anxious you must have been for my safety. Let me tell you that we Americans over here are a part of the American Expeditionary Forces and as such will be taken care of by our troops, so don't worry about my falling into the hands of the enemy. One afternoon a number of American boys came into the canteen. I had the regular big white apron and long blue veil on. After I had talked a minute, asked them what they wanted and was turning to go, when I heard one say to another: 'she sounds like a real American girl.' I turned and retorted 'Well you just better not suggest I am anything else.' Then I wish you could have heard them. They said they had been among those who sailed from New York on June 14, 1917 and they hadn't had a chat with a real American girl in all that time. Oh, our boys are so wonderful. I am so proud of them. I have been to the hospital and seen them suffer, fearful suffering it was. I have seen a boy die from the awful gas; I have heard them talk; have played to and sung with them, they are simply great.

One of the boys left a lot of popular music at his pension (you can't get it here). I take it with me to the hospitals and to the place of recreation where there is a piano and I wish you could hear those boys sing. They love it and they are so very grateful for any little attention. I have especially adopted four patients just now, one from Ypsilanti, one from Hot Springs, Ark., one from New York and the other from Salem, Mo. One of them said to me (he is the dear boy who just graduated from Lafayette College last spring), 'Do you know there are just three things I look forward to each day.' When I asked him what they were, he said, 'Three good meals, a glass of milk and you to talk to me of home and read to me.' He and I are reading 'Ibsen.' He has been over here three months and has not received one bit of mail which is still chasing him around the country. Today I was fortunate, so I shared my mail with him; I read him a portion of mother's letter. He remarked 'I like your mother's letters; my mother writes lovely letters too.' Poor fellow, he is perfectly wild about his mother. Just talks about her all the time. 'When you get out in the trenches,' he said one day, 'only two forces count for you and they are God and mother.'

This letter excerpt is from Helen Fairbanks, an American girl, to her parents from 4 Place de la Concorde, Paris, 1917. (From the *Chagrin Falls Exponent.*)

The first man from Chagrin Falls village to give up his life for his country was Melvin C. Eames. Mr. Eames lost his life when the steamer Ticonderoga was shelled and torpedoed and sunk in mid-ocean on September 30, 1917. A telegram received by his wife this Monday from the War Department confirmed the sad news. Tuesday afternoon papers also published his name in the list of missing. There were 11 officers and 99 seamen in this list. Eleven naval officers and 102 seamen were also lost.

According to survivors, the Ticonderoga had fallen 10 or 15 miles behind the other ships of the convoy, being unable to keep up. About 5:20 a.m., the ship was attacked and shelled by a submarine and a battle followed. The Ticonderoga was hit repeatedly, her wireless and bridge carried away and the ship generally badly shot up

Survivors on the ship ran up a white flag but the shelling still continued. Only one of the ship's boats got away clear. Some of the men escaped on a raft. It is reported that the two Americans who escaped in a small boat were fired upon by the Germans and taken prisoner.

There are no details available of the fate of the various individuals on the ship, and what became of them can only be surmised. Mr. Eames was 25 years of age, having been born and raised in Bainbridge. His parents are both dead. Three sisters and two brothers survive him. He was married on June 6, 1917 to Amelia Cipra of Bainbridge, who survives him.

This letter excerpt is from Melvin C. Eames on the lost *Ticonderoga*. (From the *Chagrin Falls Exponent*.)

Received November 29, 1918
AEF, France, November 8, 1918

Dear Father:

A few days ago I wrote that I had a part in the show of November the first, said now to be the last stroke for Democracy. Today at noon a courier brought news that last night at eight o'clock the armistice had been signed at Versailles and all the French people at No. 714 were out giving true vent to their overjoyed souls and weary beings. I saw big fellows who had been through the early show, wounded and sent here, stand back from those singing at the piano and big tears in their eyes, tears of joy and sorrow. They never speak their thoughts but their serious set faces speak silent words. Others sang, talked, and laughed excitedly, for it surely was great news. What will the papers say/ and has activity along the front ceased are pertinent questions unanswered. Every man here is too ready to go on further if necessary, the same spirit that has shown all thru, for they would really like to have the German people feel the terror that grips one when the invading army is at their Capitol gate. Make the devils swallow some of their own frightfullness However, we must be sane, for that would be the only true way to close negotiations. It's lucky, nevertheless, that I am not on that board at Versailles...

It's more like a dream now and makes me feel sad for the whole day passed so quickly, and so much happened it seems like I had read a book of wild adventure. We were out at four and moving. I followed the guides with the others, we moved through the German barrage to our position for the jump off. While moving up, Lieut. Russel, the fellow I had slept with, ate with, and dodged shells with, went down and I found myself in command of the company. Dad, I don't think I looked scared but I was . . .

Chagrin Falls Exponent

Three Chagrin Falls boys figure in the casualty lists in the past week. H.L. Stoneman of South Main Street received an official message last week Tuesday announcing that his son, Albert Stoneman, was missing. The missing soldier had not been heard from for some time and his parents are still hopeful that they will hear good news from him in a short time. He belonged to Co. B, Eighteenth Infantry. Private Stoneman went to Camp Gordon, Atlanta, last June and was sent across after a few weeks training.

PRIVATE CARL O'NEIL'S NAME APPEARED IN THE PUBLISHED CASUALTY LIST LAST WEEK AS BEING WOUNDED, DEGREE UNDETERMINED. HE BELONGED TO CO. G, 310TH INFANTRY.

B.R. HOOPES HAS RECEIVED A WAR DEPARTMENT MESSAGE ANNOUNCING THAT HIS SON, SERGEANT HARRY HOOPES, WAS WOUNDED IN ACTION, OCTOBER 7TH.

March 13, 1919
The boys were homesick as they awaited the ship for the U.S.A.

The following letter from Maurice Shumaker may be the last from him written on the other side, that the Exponent can publish. Mr. Shumaker is expected home at any time and may be on the ocean by now. The letter follows:

Rouen, France, February 15, 1919
Dear Folks At Home:

No doubt that you will be surprised to learn that we are still in Rouen. Just when we shall get away we do not know. But it does begin to look as tho we would soon get started for the U.S.A.

We have had our final physical examination, embarkation papers O.K.'d and all our clothing taken away, except our traveling clothes. The entire hospital equipment and paraphernalia have been checked and turned into the B.E.F. Ordnance. We should have been home several weeks ago but army red tape is an endless affair. It almost gives us the heartache to see other units leaving for home and here we are still carrying on. I'm sorry to say that a few of the boys will be left behind for a few months to recuperate.

I have just passed my second birthday in France and on the 8th of March will receive my 3rd chevron or service stripe. I have received the wedding invitation of Lloyd Sherman who is to marry a little French girl and take her home with him.

The following is from the *Chagrin Falls Exponent*, regarding a historical assemblage in Chagrin Falls Park:

Honored were the men who had returned from the war. Each man's name was called off and he stepped forward to receive his medal from the hands of the town representative. This, it was said, was the first time in the history of the town that soldier and sailor boys returning from the war, were ever thus assembled and honored.

It is prophetic that the last sentence in the article read "At least all hope there will be no war that would precede such a demonstration."

Nine
The End of the
Beginning

PEPPER PIKE. This photograph was taken on the original site of the Garfield Memorial Church in Pepper Pike. (Photo by V.L.)

Throughout the villages there were men and women who served and fought to preserve liberty and freedom in the great battles of this country, from the French and Indian War, the War of 1812, the Mexican War, the Civil War, the Spanish-American War, World War I, World War II (1941–1945), to all the wars that followed. The names of all who served remain as living monuments in the village greens, in the cemeteries.

By the beginning of World War II, the government had taken control of nearly everything that Americans could do. Coupons, rationing, census, job control, wages, Federal Income Tax, and the draft were all under government control. New names appeared in village newspapers—President Franklin D. Roosevelt, British Prime Minister Winston Churchill, French President Charles de Gaulle, Benito Mussolini, Joseph Stalin, Admiral Isoroku Yamamoto, and Pearl Harbor.

We were no longer just the village, we were the world.

From a population of 1,063 people in 1850, the population in the villages and townships continued to grow. In 1950, Pepper Pike and Solon were the fastest growing communities. Pepper Pike showed a gain of 107 percent, and Solon showed a 70 percent gain. Bentleyville would show a 30 percent increase between 1940 and 1950, and Chagrin Falls Village increased by 23 percent. Chagrin Falls Township increased by 129 percent; Gates Mills showed a 17 percent increase; Hunting Valley increased by 28 percent; Moreland Hills gained by 85 percent; and Orange Village gained by 82 percent.

The period of 1935 to 1945 saw the beginning of the modernization of American medicine. Penicillin, one of the greatest discoveries of our time, came into existence in 1928—more than a decade before the onset of World War II. By the time antibiotics were in wide use near the middle of the 20th century, the life expectancy rate in the United States had increased by nearly 20 years.

STONEMAN FAMILY GRAVEPLATE, LANDERWOOD CEMETARY. (Photo by V.L.)

MT. HOPE CEMETERY AT THE INTERSECTION OF HARPER ROAD AND MILES ROAD. (Photo by V.L.)

The following is from the September 1943 writing, *Historical Sketches of the Village of Gates Mills*, by S. Prentiss Baldwin:

The thousand acres of woodland are fortunately made beautiful by nature, without human care, but the thousand acres would look desolate, indeed, if we did not become farmers and turn them into fields of grass, for hay and pasture. The same fatherly forethought safeguards our future, with restrictions on all the land forever forbidding the sale of all liquors, and great advertising signs are forever barred.

True again to its New England history, the village welcomes and even rejoices when the cold of winter comes down upon it; and when the snows pile high on the hills, the roads are cleared for the big double coasters, while skates and skis appear. Then, in the melting month of March, the sugar camps are opened and the odor of boiling sap drifts over the hills, with its invitation to all to come.

And when the buds and a million flowers of April burst forth about us, the village, having scarcely slept at all, wakes to greater life than it ever knew in the old stagecoach days.

It seems hardly necessary to add that simplicity, the keynote of the transformation three years ago, pervading the Inn and the village, is today also the keynote of the social life of the lovers of nature who have since been building homes on these hills.

THE HARPER ROAD CEMETERY.

A HARPER ROAD CEMETERY
GRAVESTONE. (Photos by V.L.)

A Tombstone of the Pike Family
in Mt. Hope Cemetery.

A Harper Gravestone in Mt.
Hope Cemetery.

A GRAVESTONE FOR BABY HARPER.

FRANK C
ROWE
CO G
19 US INF
INDIAN WARS
APR 22 1853
DEC 6 1899

GRAVESTONE OF FRANK C. ROWE ON HARPER ROAD IN MT. HOPE CEMETERY.

124

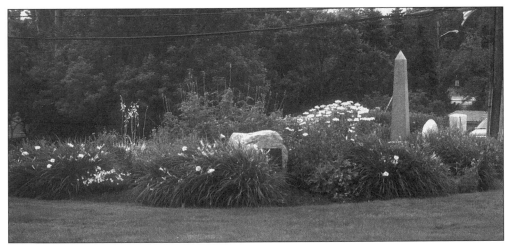

JACKSON FAMILY BURIAL GROUND. In a tiny burial ground a few feet from Pinetree Road (the old Kinsman Road), the Jackson family, who were among the early settlers of Orange Township, rest in peace. Bodies of the members of the family were removed after the 104-acre farm was sold to the Van Sweringens in the 1920s. Attempts to remove the pioneer couple were unsuccessful because permission could not be obtained from their scattered descendants.

The tombstone shows that Raw Jackson came to Orange in 1835 at the age of 46 from his native Yorkshire, England. The following year he sent for his wife and nine children. Jackson died in 1859; his wife died 10 years later. Several of their sons bought farms in the township. Jackson Road, which runs through Orange and Moreland Hills, is named for the family. Keyes Treuhaft acquired the land after World War II. The cemetery is separated from the parking lot by about 50 feet of lawn.

HISTORIC LANDMARK
MARKING THE SITE
FIRST SETTLED IN
ORANGE TOWNSHIP OF
THE CONNECTICUT
WESTERN RESERVE.
(Photos by V.L.)

THE ENTRANCE TO GROVE HILL CEMETERY IN
CHAGRIN FALLS.

THE JACKSON PLOT AT LANDERWOOD.

The locations of the early communities have no remaining buildings, and only cemeteries exist as tangible reminders of pioneer life. Orange Hill Settlement was located where S.O.M. and Pinetree Road now meet. The North Solon Settlement was approximately at Miles Road between Lander Road and Brainard Roads. Orange Center Settlement was at S.O.M. and Pinetree Road.

Each group had its own school and cemetery. There were ten schools within the Orange Township boundaries.

John, Ann, and Mary Stoneman are buried in the cemetery on the south side of Pinetree Road, immediately east of the shops on the south side of the street.

The Lander Circle, or British Church Settlement, was at the intersection of Route 422 and Lander Road. Four smaller settlements existed at Burnett's Corners where Brainard Circle and Shaker Boulevard now meet. Henderson's Corners existed at the crossroads of Fairmount Boulevard and Chagrin River Road. Where S.O.M. and Jackson Road come together is where President James Abram Garfield was born.

James Garfield, 20th president of the United States, is buried in Lake View Cemetery, Cleveland, Ohio—Specific Interment Location: Section 15.

Mantis James Van Sweringen is buried in Lake View Cemetery, Cleveland, Ohio—Specific Interment Location: Section 30

Oris Paxton Van Sweringen is buried in Lake View Cemetery, Cleveland, Ohio—Specific Interment Location: Section 30

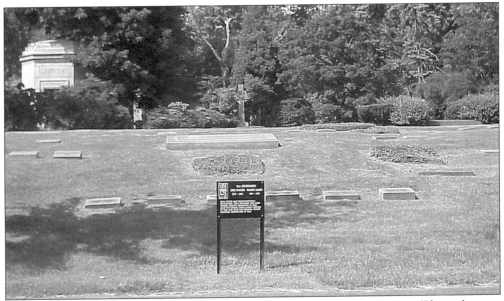

VAN SWERINGEN BROTHERS AND FAMILY BURIED IN LAKEVIEW CEMETERY. (Photos by V.L.)

There were no battles fought in the cemeteries of the villages. These private places in winter are hidden by the snow and resurrected in spring. They are now quiet reminders from which we can observe the heart of the village. Part of the landscape is nestled in the hillsides and surrounded by trees and stone walls. The land has not grown—the villages have spring up around them. The mills and factories have disappeared; the villages today, with their enduring charms, are all places of serenity and beauty. Buried in our midst are the people who made it possible for us to be here—"between the river and the wooded hills."

—Vel Litt

(Photos by V.L.)